MARTIN LEMAN

MARTIN LEMAN

A World of His Own

David Buckman

Sansom &
Company

First published in 2002 by Sansom & Company Ltd.,
81g Pembroke Road, Bristol BS8 3EA
Tel: 0117 9737207 Fax: 0117 9238991

Illustrations Martin Leman
Text David Buckman
ISBN 1 900178 98 2

British Cataloguing-in-Publication Data.
A Catalogue record for this book is available from the British Library.

Designed by Stephen Morris, Liverpool and Bristol, smc@freeuk.com
and printed by HSW Print, Tonypandy.

CONTENTS

A World of His Own 7

Away with Adverbs and Algebra 8

In Defence of the Realm 11

Art School 12

Hiring and Firing 14

Changing Direction 16

Chess in Washington Square 18

Making His Mark 21

The Cornish Connection 23

His First Book 26

A Publishing Phenomenon 28

Nudes 31

Still Lifes 35

The Paintings **36**

Exhibition History 108

Martin Leman Books 111

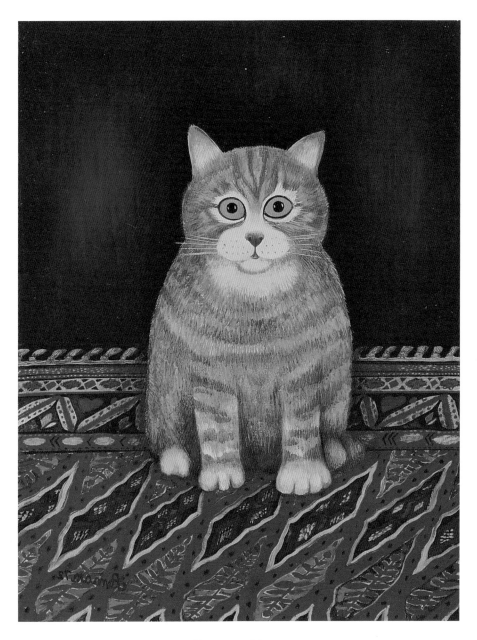

Cat on Mat

Oil on board 20.5 x 15 cm 1972

A WORLD OF HIS OWN

Images become the wallpaper of our lives. We see them so often that frequently we do not really see them at all. Good examples are advertisements, which appeal to us from roadside hoarding, in the Underground or every time we open a newspaper or magazine. They linger in memory long after the products have ceased to be available.

Rare artists achieve this quality of entering the subconscious. Obvious ones are cartoonists: the Lows, Schulzes and Giles, producing a daily or weekly reminder of their names and images. Occasionally, painters achieve this almost subliminal fame, and among the most successful now working is Martin Leman. With over half a million books sold, backed up with a long string of exhibitions, the Leman cat has become a modern icon. It was so much in demand that it found its way onto postcards, calendars, jigsaws, trays and tins. For Martin's fans who want a bit of variety, there are also Leman nudes, still lifes and assemblages.

In 1985, with his wife Jill, Martin published *A World of Their Own*, a collection of their favourite twentieth-century British naïve painters. These are artists with an urge to reveal the often magical worlds that they alone see, even though they may be untrained in the use of materials or hazy about the rules of perspective. The range of subjects can be narrow and technique limited, but sincerity overcomes all. Although he is sometimes classified as a primitive, Martin Leman is in reality a highly trained, sophisticated and versatile artist who chose to paint pictures in the primitive manner. His paintings are a fix, a window into a private world of his own.

Martin Leman – pronounced Leeman – was born in south London in 1934. His father, Arthur, was a fruit merchant, who started off as a porter in the old Covent Garden market. Arthur married Eileen Mahoney, Martin's mother, and by the time the boy was born Arthur had his own business in the Covent Garden arcade, which Martin remembers visiting with affection.

Life for the Lemans, like so many others, was to be disrupted by the start of the Second World War, when Martin was five. In 1939, Arthur joined the Royal Air Force, and after completing his required number of bombing raids over Germany was transferred to fighters in Burma. The family was then living in a flat in Streatham, where Eileen was to run a bridge club, being a very good player. This interest Martin was eventually to share.

South London was an area vulnerable to enemy raids, so Martin and Mary, his older sister, were evacuated when he was about seven. She to a convent in Somerset and Martin's boarding school, near Reigate in Surrey, moved to South Wales, where it continued to operate. They were there for about a year.

Martin remembers fondly: 'I have been back to the street, in a small village called Llandbradach, although I can't remember the name of the people I lived with. The man of the house was a miner, so was his son. They would go off to work at the crack of dawn and come back, covered in coal dust, to a bath in front of the fire. For entertainment we boys used to sit on a slag heap behind the local cinema listening to the soundtracks of cowboy films.' His love of film, another key interest, began to develop.

Back in Streatham, Martin went to a Roman Catholic school, where he remained until his father was killed in 1945 in a plane crash in Burma. His mother now faced some tough years, with two small children to bring up. One plus factor for Eileen was that Arthur had been a freemason, so Mary and Martin were assured the opportunity of a sound and free education at the Royal Masonic School in Bushey, Hertfordshire. Two years older than Martin, Mary went on to become a top model in Paris, working with Dior and then Balenciaga.

At school the only subject Martin looked forward to, and was good at, was art. Many visually creative people found it difficult to cope with the essay writing that the school examination system demanded in the 1940s and Martin left the Masonic School without any qualifications. It just happened that he had an inexplicable itch to be an artist, which was advanced when he entered Worthing Art School. He was now on the first steps of what was to prove a rather shaky career ladder.

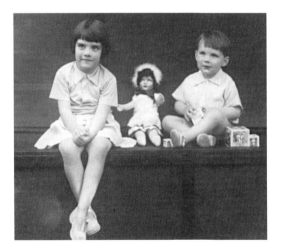

Martin and his sister Mary
London 1938

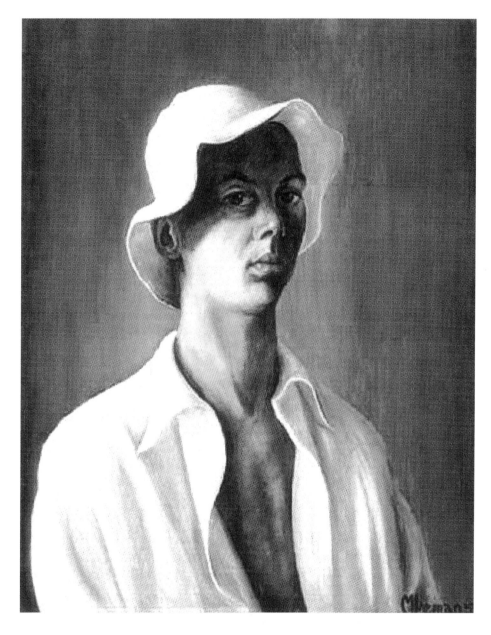

Self portrait at Worthing Art School
Oil on canvas 51 x 40.5*cm* 1952

After the war, young men were still required to endure a period of National Service in one of the armed forces. Unlike his father, Martin found himself in the army. After basic training at Aldershot he was posted to Egypt, on a troop-ship, for two years. Disembarking at Suez, he went by train and truck to Tel el-Kebir, near Ismailia; the camp was known as the worst posting in the British Army, because conditions were tough – desert, heat and mosquitoes. Incursions into Tel el-Kebir were part of the growing tension before the Suez Crisis blew up in 1956. President Gamal Abdel Nasser announced nationalisation of the Suez Canal, which was accompanied by increased hostility towards Israel. It was not long before Britain and France launched controversial military action. Martin was fortunate to be out of Egypt before hostilities began.

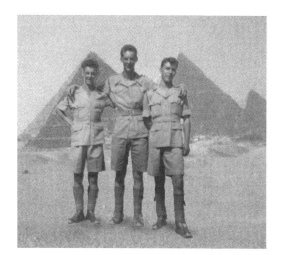

Egypt 1955
Martin in the middle

ART SCHOOL

Out of the army in 1957, Martin continued his education at the London Central School of Arts and Crafts, that impressive domed building in Southampton Row, on the edge of artistic Bloomsbury. When it was opened, in 1896, the emphasis was on applied art. Over the years many notable engravers, bookbinders, embroiderers and metalworkers, as well as painters and sculptors, have learned their crafts there.

The painting department was quite keen on his work, but he nevertheless decided to go for graphic design, realising he had to earn a living.

One notable painter Martin did encounter was William Roberts. He was a notoriously taciturn individual but a fine draughtsman, famous for pictures of tube-like people and animals which were shown regularly at the Royal Academy Summer Exhibition. Martin remembers Roberts as a rosy-cheeked man who taught the life class occasionally, and who would correct your drawings. Mainly, of course, he was taught by typographers and new-wave graphic designers.

Even though he was getting a grant, he needed more money, so he got up at five in the morning and cycled to Berkeley Square, where he would scrub floors and empty fireplaces at the princely sum of one and ninepence an hour. Martin had for years tackled any job that was offered to support himself.

He was at Central School for about two years, but left before completing the course – impatient to start some real design work.

Martin in his studio
Islington, London, 1975

HIRING AND FIRING

On leaving Central after two years, Martin's priority was to find a job. In a profession notable for hiring and firing, there was a lot of firing in the ensuing two or three years. Initially, he considered his luck was in when he landed the job of art director on a photographic magazine.

Martin recalls: 'I thought, right, I'm art director, so here we go, I'll re-design the magazine. It was to be Swiss graphic design, sans-serif type, a lot of white space.....the proofs came back and they looked absolutely gorgeous – but I was fired! The editors had rung up and asked what had happened to all the copy. The magazine was a traditional and unchanging layout: 10-point solid type, two columns. That's how the editors wanted it. What I had designed was not the magazine that normally appeared. They clearly didn't want a creative graphic designer. I understood perfectly. I had actually learned something.'

After his one-issue term, his next job was a complete contrast and lasted all of six months. He joined a book publisher in Kentish Town as typographer/designer. Then he moved to a smart advertising agency in Mayfair which had on its books clients like Nestlés. Next, six weeks later, aiming high, he switched to S H Benson, an old established agency with among its clients household names Guinness and Bovril. The detective story writer Dorothy L Sayers, creator of Lord Peter Wimsey, had worked for them, which was the background to her successful 1933 book *Murder Must Advertise*.

'The reason I now think that I seemed to get every job I applied for was because, although I was hard up, living in a tiny room in Kentish Town, for an interview I would wear a stiff collar and tie and carry a briefcase and look confident and successful.'

At Benson's Martin used to point to the sign 'Creative Typographer' above his desk, but there was no opportunity to be creative: to do, say, a layout with a couple of lines of type and a big white space. He lasted about two months. Martin's next job was, initially, more to his liking.

He went to Hans Schleger, a very nice man who had a studio in South Kensington with a staff of six. Schleger agreed to take him on for a couple of weeks, to see how he would get on. Schleger, a naturalised British subject born in Germany, also known professionally as Zero, was one of the most respected designers of his day. 'He used to do things beautifully', recalls Martin.

He goes on: 'After the trial period, Schleger said I could stay. It was a lovely job, but I had something else to go to. I wanted to do my own work. I could have been with Schleger forever, but it was too cosy, too settled. On Fridays there would be doughnuts and cups of tea and a few drinks before you went home – in my case to a room in Kentish Town! Following Schleger's, I joined a pharmaceutical firm in Welwyn Garden City. When I went to Welwyn I had bought a huge 1930s Austin for £30, useful for chatting up some of the secretaries, which must have made me seem a fairly dubious character.'

He enjoyed the job in Welwyn, designing the firm's brochures and house magazine. These were beautifully printed with no expense spared. However, he was soon fired. An issue of the magazine which circulated around the staff included a picture of the directors to which Martin had added long hair and moustaches, so it was 'Goodbye Mr Leman' once again.

Still in his early twenties, resilient and adaptable, the hurdle of yet another sacking was an obstacle Martin soon overcame. He explains that after the Welwyn job he joined a small art agency in Fleet Street. It was unimaginative, repetitive commercial work; when he left half the staff did, too.

CHANGING DIRECTION

After several years of job-hopping, Martin's career took a major change of direction into teaching. By that time a steadying influence was his marriage, in 1960, to his first wife Adrianne Jarratt, who was a student in the Royal College's textile department. They met and married within seven days. Elvis Presley's hit *It's Now or Never* – his best-selling single – was top of the pops.

Martin had never dreamt he would teach professionally but he saw a job advertised for a lecturer in graphic design at Hornsey College of Art and felt that he had nothing to lose and applied. About this time he had become a member of the Society of Industrial Artists. He also had in his portfolio several good examples of work. These must have made the right impression, as he was appointed and soon became an enthusiastic and innovative teacher.

His lack of experience did not prove a problem. He set interesting and inventive projects for the students they could really get involved with and enjoy, drawing on his own art school experiences to bring out creative ideas, while still relating to the more practical aspects of the commercial working world.

For almost twenty years Martin was to spend three days a week teaching at Hornsey. To this he was able to add one day a week for two years at the London College of Printing and St. Martin's School of Art, also work at Maidstone School of Art. He was also able to do his own freelance designing work.

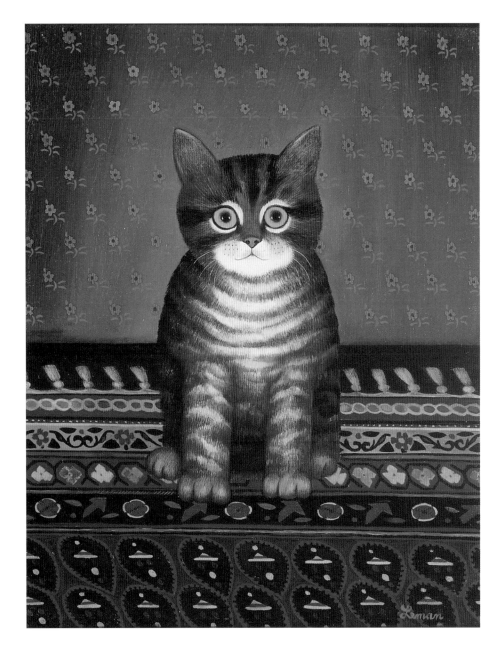

Barley Sugar
Oil on board 20.5 x 15*cm* 1974

Many today see the 1960s as a culturally liberal turning-point. Outsider publications like *Private Eye, Oz* and *International Times*, since much copied and now sought-after, gained wide readerships, especially among the young. They followed on from the previous decade, when the Independent Group at the Institute of Contemporary Arts, with exhibitions such as 'This Is Tomorrow' at the Whitechapel Art Gallery, and the activities of the Pop Artists made national press headlines. Martin made his own contribution in the mid-1960s with the short-lived, highly creative and now scarce niche magazine *Arcade*. It was a celebration of popular culture, adapting and juxtaposing common and quirky images.

The people who contributed to *Arcade* were all artists and illustrators who each paid for their own pages after the overall cost had been worked out. Contributors were free to do what they wanted on their pages. It was cheap to produce, using black-and-white litho, and only a thousand copies were printed. There were five issues between 1964 and 1967 reflecting the years of 'flower power' and the Beat Generation.

In 1967, when the last issue appeared, Martin and Adrianne visited the United States. Travelling throughout their three-month stay by Greyhound bus, they visited New York, Washington, Chicago, San Francisco, Los Angeles and finally Carlsbad on the coast where they stayed with an aunt. They also saw Hollywood, Disneyland and Mexico and Martin got to play chess on Washington Square, New York, a famous outdoor venue.

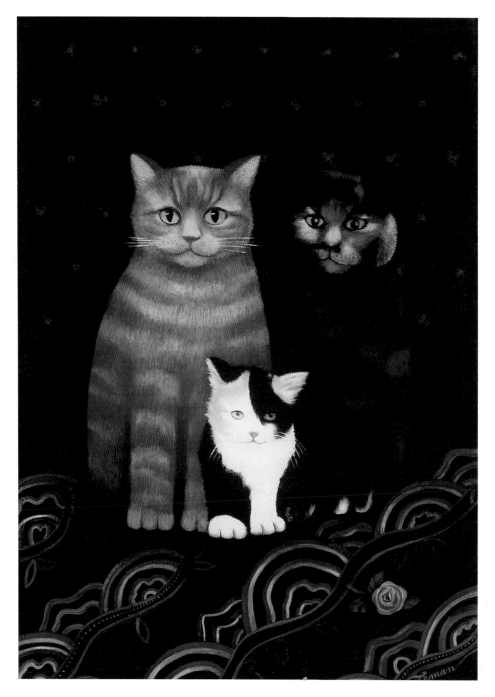

Nat's Cats
Oil on board 20.5 x 15*cm* 1973

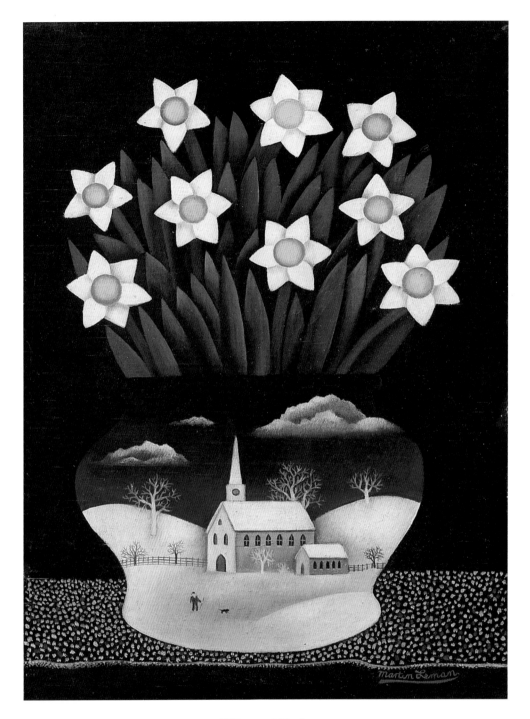

Silent Night
Oil on board 28 x 21*cm* 1976

In the late Sixties both work and personal life changed. The trip to America put a new perspective on Martin's work and in 1968 he began to paint the pictures that were eventually to bring him much success. Being by nature self-critical and having been trained as a graphic designer and typographer – branches of art and design which demand that the product is just right – in painting Martin could set his own criteria as an antidote to following a client's brief. These pictures were of imaginary bowls of fruit and flowers, in glowing colours, also small pin-ups inspired by photographs of film stars, reflecting his love of cinema.

In 1971 the Portal Gallery in London's West End began to sell his pictures. 'They agreed to take my still-lifes, took more and sold more, and it all snowballed', reflects Martin. A turning-point was the painting of a small tabby cat, sitting in a decorative interior. It sold immediately, so Martin painted another cat, a white one, which also went quickly. Like a composer, Martin had found a theme which could provide endless variations. A one-man show soon followed and that was the beginning of over twenty years associated with painting cats. A second Portal solo show followed in 1974.

The Portal had established a reputation as a gallery showing pictures by naïve or primitive artists. Their works can be seen in galleries and museums throughout the world and some of them inspired Martin. 'I had, of course, done a couple of years life drawing and painting at Worthing. As a painting student you did learn to scribble things down, get the tones right and proportions correct. Graphic design, which I eventually concentrated on, pushes you in a slightly different way. You learn how to manipulate size, composition and colour. You are concerned with tonal relationships, but tone that will stand out, reproduce and read well. I have always been inspired by Bonnard's work because it is absolutely beautiful, but if you look at it there is no drawing there at all, no substance, it is all colour and movement.

'The early Italian painter Piero della Francesca's work, which I had seen in books, influenced me when I started painting again in the late 1960s. In the 1950s I had visited Paris several times and admired the work of Henri (Le Douanier) Rousseau, with his pictures of tropical

animals and forests, as well as the circus life and other pictures of another French painter, Camille Bombois. I loved the flattened-out ladies of the self-taught artist Morris Hirschfield. I also admire paintings by Stanley Spencer. As far as I was concerned, these were the sort of pictures I was interested in; work with a touch of magic and humour.

'In America I saw their folk art and portraits, especially of children, which I thought superb. The American Museum in Bath has always been a source of inspiration – it has a delightful gallery of folk art portraits and many other treasures.

'I think the primitives are terrific, absolutely fantastic. I love them all. The Tudor portraits of kings and queens in the National Portrait Gallery are stunning pictures. They may be stylised, but look at the craftsmanship, the clarification, the drawing, design and colour.' Among Martin's own collection is a picture by Scottie Wilson, a self-taught painter who produced minutely detailed paintings and plates decorated with totem pole-like funny faces and tiny birds. 'What are called primitive paintings just make you smile. It's fun, they are romantic and the colours are terrific.'

In 1971, the year of Martin's first solo show at Portal, his personal life also changed direction again with his marriage to second wife, Jill Winthrop.

Although Martin has always lived and worked in London, he has a strong attachment to Cornwall. 'I love the sea there, the beaches and the swimming. We used to go to Newquay on holiday when I was a boy.'

In the 1970s the Lemans went to Cornwall regularly – first staying in Penzance and then St

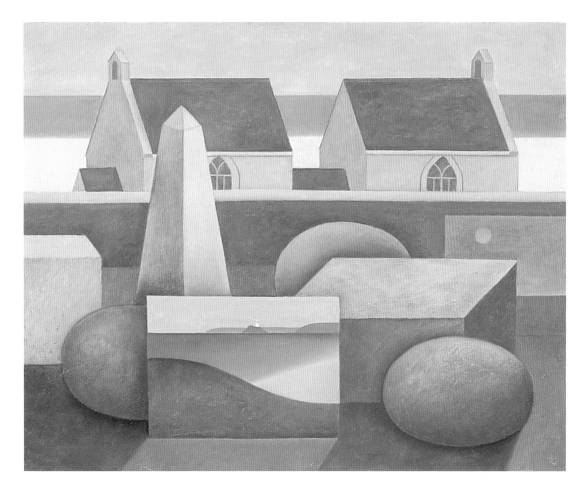

Barnoon, St Ives
Oil on board 25.5 x 38 *cm* 1991

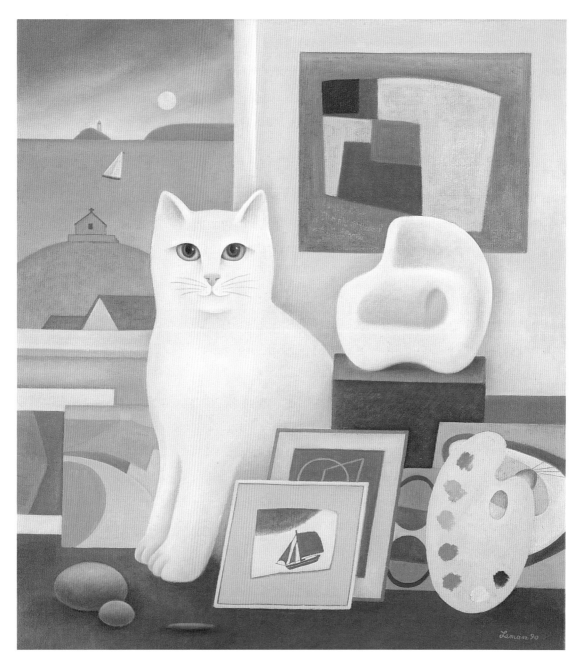

Painting for fund raising print for Tate, St Ives
Oil on board 44.5 x 41*cm* 1990

Ives – during the long summer teaching holidays, exploring the Penwith peninsula in depth.

Cornwall, of course, has strong artistic associations, but the main draw for Martin was the sea. 'I did learn a lot through being in St Ives, though. The stronger light means that colours down there are brighter, so my darker interiors made way for more outdoor, lighter pictures.'

It was when a friend was staying with Jill and Martin that Martin discovered the Wills Lane Gallery and its director, Henry Gilbert, who has shown many of the famous Cornish artists. Martin exhibited his cats at Wills Lane over a ten-year period with great success, and eventually at the New Craftsman and the Sims Gallery.

He began painting the resident cats of the town, sitting on the harbour, or with a piece of fish. He also painted the landscape of west Cornwall and details of St Ives: Smeaton's Pier, the Island and Godrevy Lighthouse often appear in his work.

He gradually cemented his relationship with the town. 'I painted a picture of the Wills Lane Gallery, with a grey cat sitting on the doorstep, and when the book *Art About St Ives* was published in 1987, the picture was featured on the cover.' In 1993 one of Martin's characteristic 'St Ives' paintings was made into a limited edition print, the sales of which went towards the funding of the new Tate St Ives Gallery.

'In 1977, Joanna Goldsworthy, children's books editor of the publishing firm Victor Gollancz, discovered me for the publishing world. She had seen my work and asked me to do my first cat book. I had no idea that it would eventually lead to more than two dozen books over the next twenty years or so, as well as calendars, greetings cards, portrait commissions and so on.'

The first Gollancz book, *Comic & Curious Cats*, paintings by Martin Leman, words by Angela Carter, appeared in 1979. Joanna's choice of Angela Carter was shrewd; she had established a singular reputation as a novelist, poet and essayist, whose macabre, witty, surreal work – derived from such inspiration as fairy tales and folk myths – had won her several major literary prizes. *Comic & Curious Cats* was translated into several languages, including Japanese.

Martin's cats fall into two groups. First, the designed cats, as in *Comic & Curious Cats*, which reached a world-wide audience in the 1970s and 1980s. They all have a touch of humour. Secondly, there are the commissioned cat portraits, which are more realistic. 'I photograph the cat and paint the portrait in my own style. If the owner does not like the result, they do not have to buy it, although this has never happened.' Sir Roy Strong, the writer and former head of the Victoria & Albert Museum, is one satisfied client. Over the past 30 years Jill and Martin have had cats of their own who have all appeared in paintings.

Success with his pictures in exhibitions and the offer of *Comic & Curious Cats* nudged Martin into full-time painting in the late 1970s. After twenty years of teaching, it was time for a change.

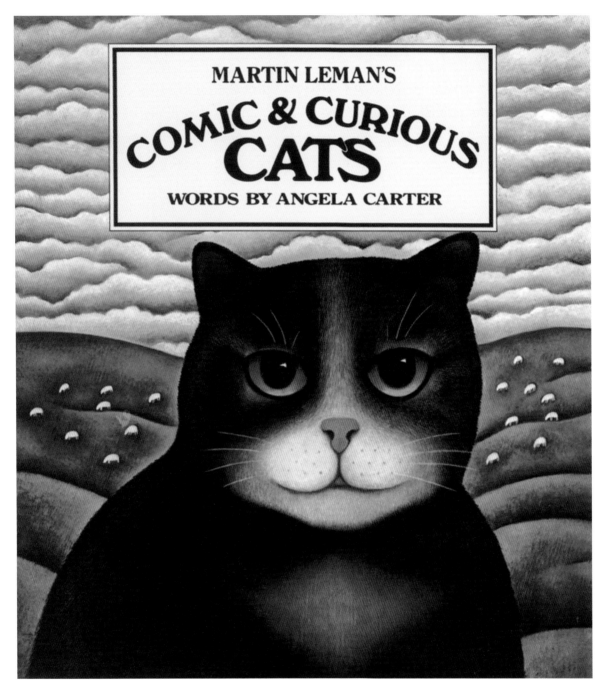

The cover of Comic & Curious Cats
Oil on board 30.5 x 30.5 cm 1977

Comic & Curious Cats was the beginning of what became known in the publishing world as 'The Martin Leman Sales Phenomenon'. By 1990, Pelham books, now Martin's main publisher, could claim that it had sold over 460,000 copies of his books and calendars. *The Teeny Weeny Cat Book* sold 55,000 copies in two years and cat calendar sales hit 44,000. Lemania developed as fans bought up Martin's distinctive images, reproduced on cards, calendars, boxes, trays and jigsaws.

In the seventeen years after *Comic & Curious Cats'* appearance, Martin was involved in another twenty-five books. Three titles came out in 1990 alone. Jill, with her experience in publishing, was an invaluable and imaginative collaborator. In 1980, Gollancz followed *Comic & Curious Cats* with *The Book of Beasts* and Pelham published *Starcats*.

After three more cat books, *Lovely Ladies*, a collection of Martin's nudes, was published in 1984. 'A lot of the paintings were very old, but fortunately I still had all the transparencies.'

A World of Their Own, which followed in 1985, was a unique Jill and Martin collaboration. Taking up the recent growth of interest in naïve and primitive artists, they collected the work of forty-four such painters, with an essay on each. Martin knew most of the artists and was able to get material from them.

The attractive book included famous names like LS Lowry and Beryl Cook; also many who were not so well-known, but who nevertheless produced outstandingly original pictures. Martin was represented by two typical cats as well as by a singular green, maze-like picture *The Secret Garden* which, like *Lovely Ladies*, indicated that he was much more than a feline specialist.

Martin Leman's *Teddy Bears* appeared in 1989 and like *Catsnaps* before it, showed his talents as a photographer. More originality produced *Needlepoint Cats* in 1990 and *The Square Bear Book* appeared in 1991. Another photographic book, *Just Bears*, was also a success.

The Best of Bears, more photographs, which followed in 1994, was the last bear book and the end of Martin's long association with Pelham, all remaining titles being concerned with cats and from other publishers. Pelham did produce one other feline title, *My Cat Jeoffry*, in 1992 – the first time a book had been devoted to a single writer, the eighteenth-century poet Christopher Smart.

Gollancz, publisher of Martin's hugely successful first book *Comic & Curious Cats*, re-entered his life in 1990, producing *Curioser and Curioser Cats*, followed in 1993 by *The Little Cat's ABC Book*. In 1994 they published *Cat Portraits*; and finally, in 1995, *Ten Little Pussy Cats*. Orchard Books' *Sleepy Kittens*, in 1993, and Brockhampton Press's *Martin Leman's Cats*, of 1996, completed the run of 26 Leman books.

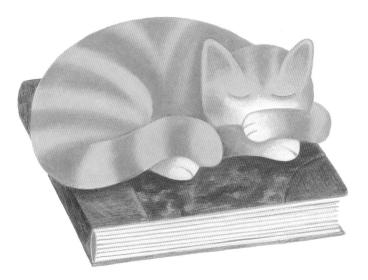

Illustration from 'The Little Cat's ABC Book'
published by Gollancz 1993

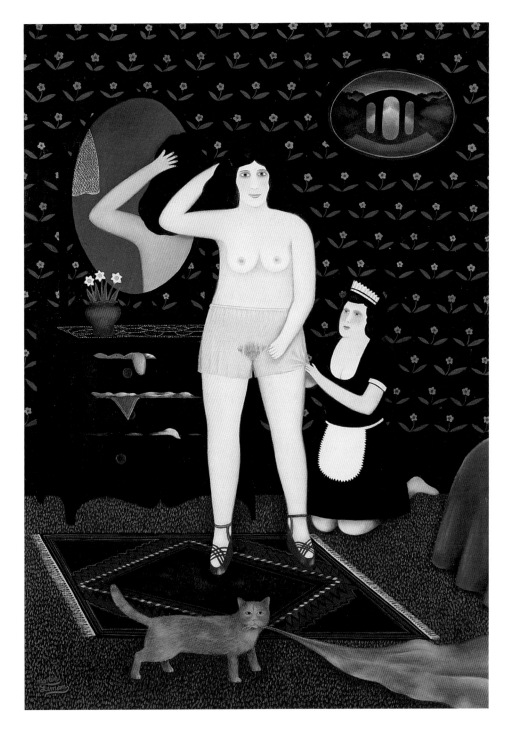

Dressing for dinner
Oil on wood 63 x 43*cm* 1975

NUDES

Alongside all the work for books, calendars, posters and prints, Martin maintains a high profile as an exhibiting artist. After the successful Portal Gallery shows in the early 1970s, he has continued to exhibit regularly. Over the ensuing 30 years, as well as solo exhibitions, notably at the Portal, Graffiti, Andrew Usiskin and Rona galleries, all in London, and latterly at the Wren Gallery, in Burford, Oxfordshire, Leman pictures have been promoted in selected mixed exhibitions in Britain and abroad.

An early important mixed show was the Arts Council's 'Body and Soul', at the prestigious Walker Art Gallery, in 1976. 'It was fun', recalls Martin. The influential critic and curator Norbert Lynton went into the Portal one day, saw his nudes, and chose twelve of them for the exhibition. Although some of the artists in the impressive catalogue were not well known, others were. Martin's pictures were hung alongside such luminaries as Francis Bacon, Norman Blamey, Patrick Caulfield, David Hockney and Euan Uglow.

Martin has great affection for his nudes. He never uses models. 'When I was a student at Worthing Art School I spent many hours over the two years painting and drawing from models, but I have not used one since then as I think I know the figure fairly well. Sometimes I refer to Old Masters, American pin-ups or other photographs, interpreting existing poses.'

The paintings are often humorous, through-the-keyhole glimpses into richly coloured private boudoirs where ladies in various stages of déshabillé are preparing to go out or simply staying in with a book, a glass of wine and their cat. The titles are an important part of the painting, like captions on a movie still – as witnessed with his *Twin Peaks*, *Blind Date*, and *Dressing for Dinner*.

When Eric Lister, a director of the Portal Gallery, published *Portal Painters* in 1982, he devoted a chapter to Martin's work and drew attention to some of the artist's lesser-known compositions. For example, he compared Martin's nudes to those of Morris Hirschfield –

praise indeed, as he was Lister's 'own favourite American' as well as an artist Martin much admired. Lister found Martin's nudes 'distinctly erotic, but never lewd' and also enjoyed Martin's 'paintings of bouquets in vases which are decorated with intricate landscapes, each separate flower carefully groomed for stardom.' Occasionally, Leman could 'surprise us with a glorious ship on a moonlit, tropical ocean, in full sail and incongruously displaying a Union Jack. Or sometimes a Pop Art dish of cookies and ice cream with other weight watchers' enemies depicted in glorious technicolor.'

Martin has been represented in mixed primitive and naïve art exhibitions in Yugoslavia, France and Switzerland. At home he appeared in a British naïve painters show at the Ikon Gallery in Birmingham, as well as similar exhibitions at the Royal Festival Hall, promoted by Stanley Harries of the Rona Gallery. These were followed by a show of British illustrators at the Chris Beetles Gallery and at a Cambridge Contemporary Art children's book illustrations exhibition.

'The Portal had several shows abroad, for example in Germany and Paris, where they sent groups of their artists to represent Britain.' Martin was pleased to have a showing in Tokyo in 1987. 'My paintings have been very successful in Japan, as in America.'

Martin enjoys seeing his work hung in a gallery and is organised for his one-man shows well in advance with no last-minute panics. He looks forward to the annual artists' lunch at the Royal Academy Summer Exhibition: 'A day to meet old friends, catch up on their news and look at paintings together.'

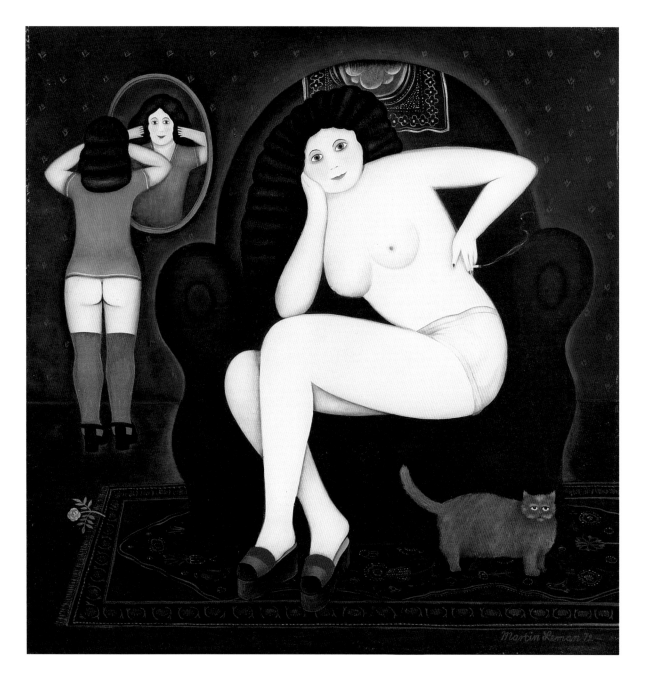

What shall I wear tonight?
Oil on board 38 x 35.5*cm* 1972

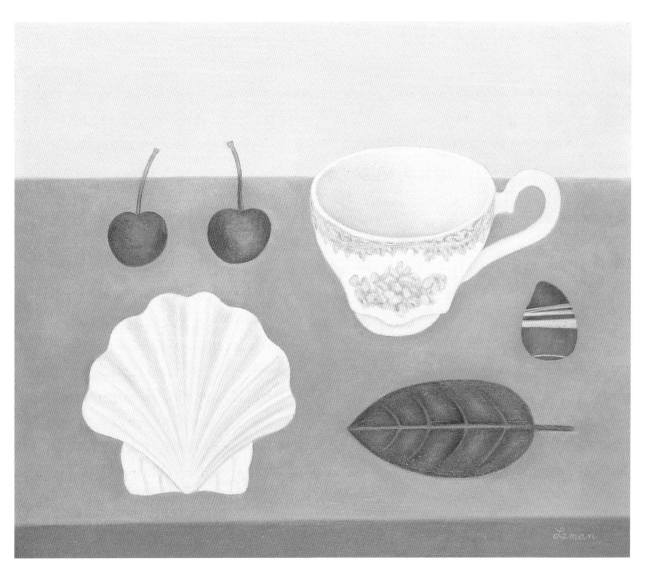

Still life with shell
Oil on board 25.5 x 30.5*cm* 1991

STILL LIFES

Anyone who knows Martin only as a painter is unaware of his versatility. At the time that he was working on *Arcade* magazine, he was also producing collages: assemblages of paper shapes to create a single picture to which painting or drawing can be added. The shapes might be chunks of newspaper type, photographs from magazines, bus tickets or other ephemera, but, in the skilled hands of someone such as Martin, they are transformed into something unique.

A collection of bottles, obelisks, miniature lighthouses from Cornwall, shells and many other bits and pieces, are a source of inspiration for past and future still lifes. In the *Hampstead & Highgate Express* review of his 1991 show at Andrew Usiskin Contemporary Art, it says that: 'Leman would invest a cream tea with spiritual significance', noting that his still lifes were permeated with 'enlightened restraint...In oils, his everyday objects, from cakes and cups of strawberries, are sealed with a silent air of infinity. A box of Ship matches might have quietly solidified, with a single match and elemental egg-like shapes. A cut avocado appears to have luminously crystallised, while even a green leaf has gained immortality. Elsewhere there are hints of the surreal or slightly sinister, as in the boy with perturbing blue eyes, clutching a red brick house.'

Although Martin Leman may on a first meeting give the impression of having a laid-back approach to his work, closer acquaintance reveals the discipline and single-mindedness that have made him such a successful and versatile artist – the name behind the paintings.

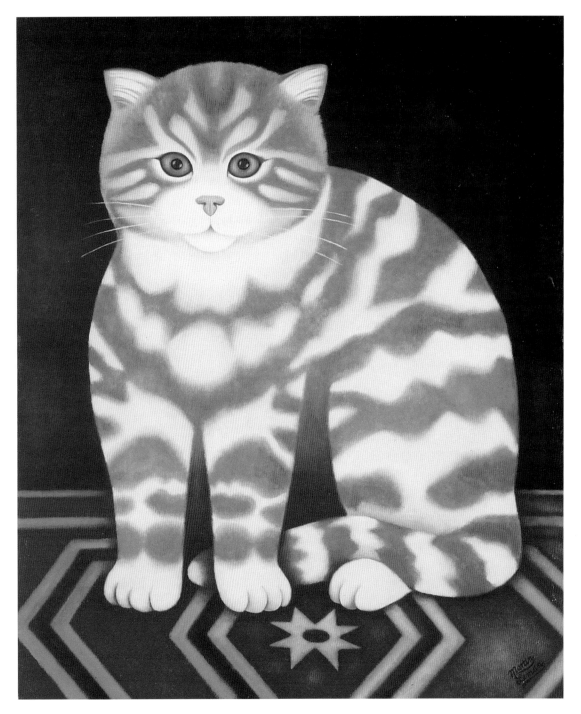

Trixie
Oil on board 45.5 x 30*cm* 1975

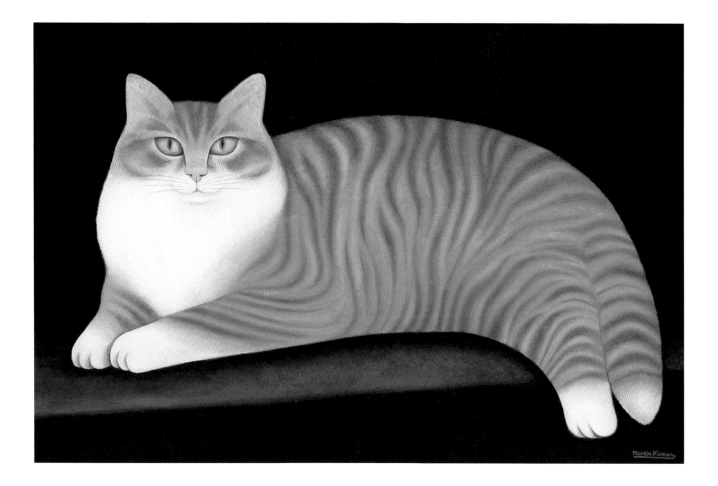

Red
Oil on board 25.5 x 40.5 *cm* 1978

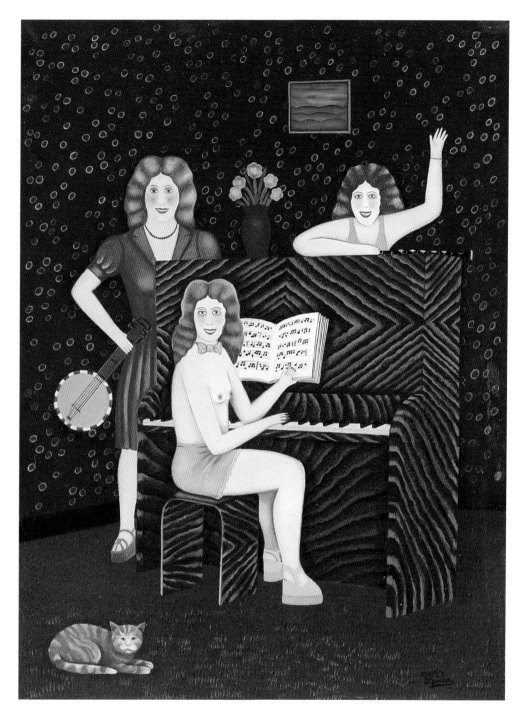

Sisters
Oil on board 46 x 34*cm* 1975

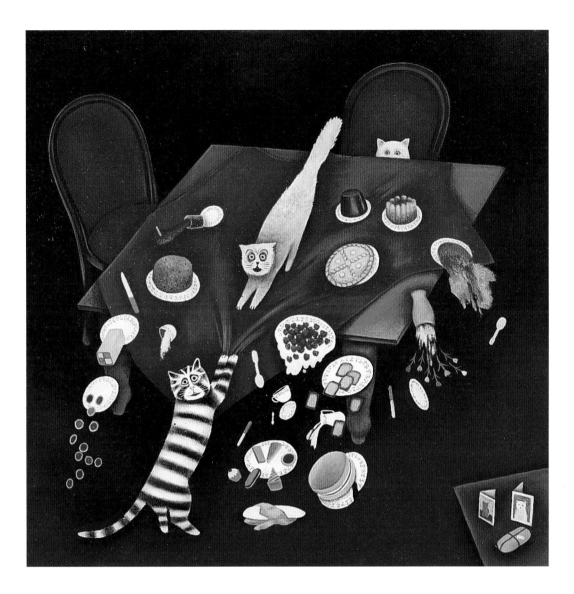

Painting from 'Comic & Curious Cats'
Oil on board 30.5 x 30.5 *cm* 1977

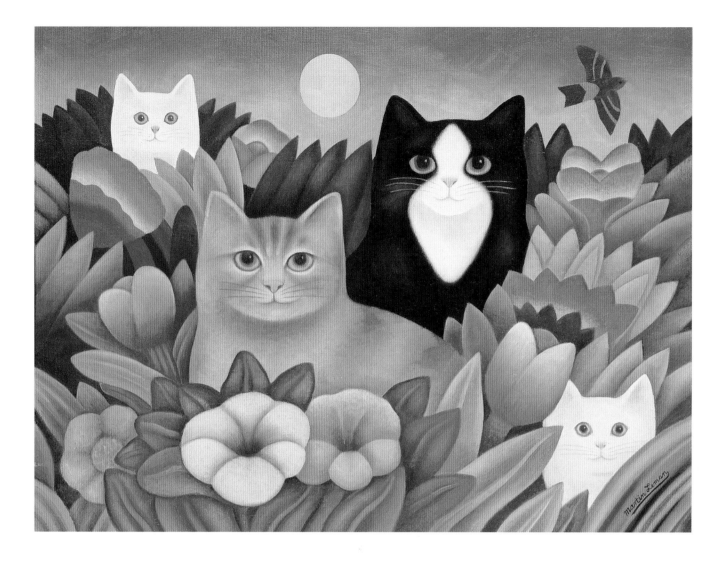

Hide & seek
Oil on board 30 x 40*cm* 1982

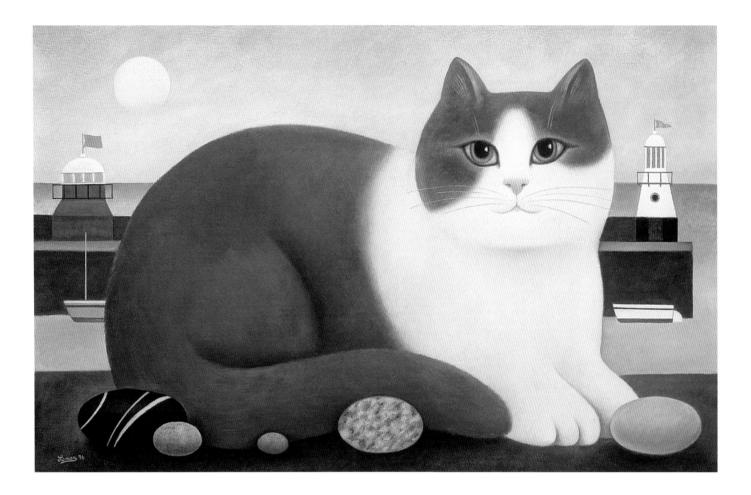

Smeaton's Pier
Oil on board 30.5 x 46*cm* 1996

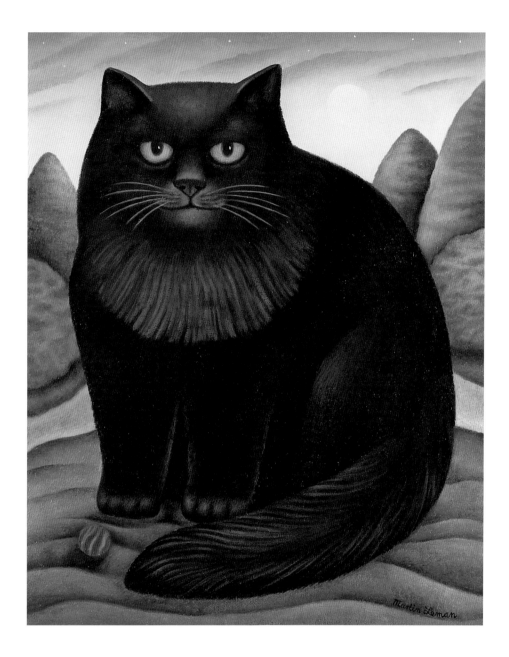

The Reverend Wenceslas Muff
Oil on board 30.5 x 25.5 *cm* 1985

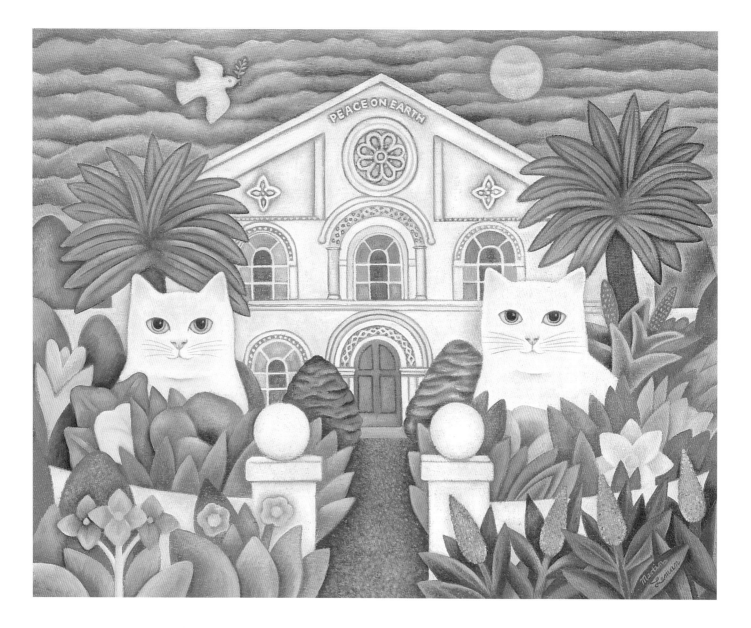

Peace on Earth
Oil on board 41 x 51*cm* 1985

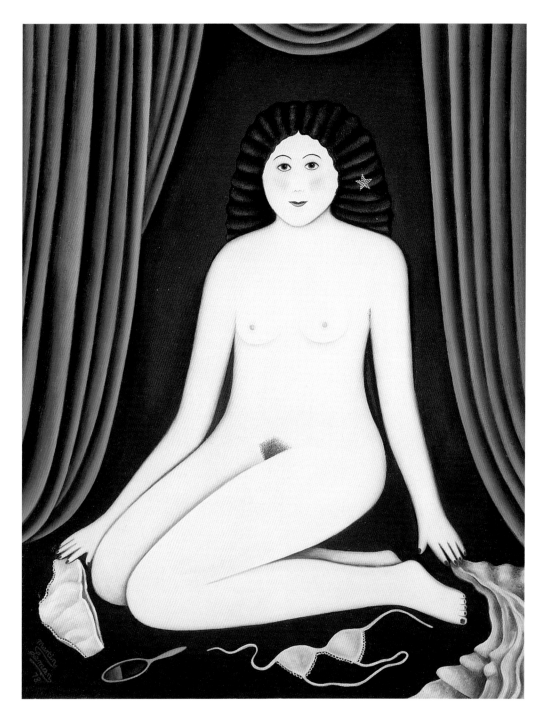

Young Lady
Oil on board 58.5 x 46*cm* 1978

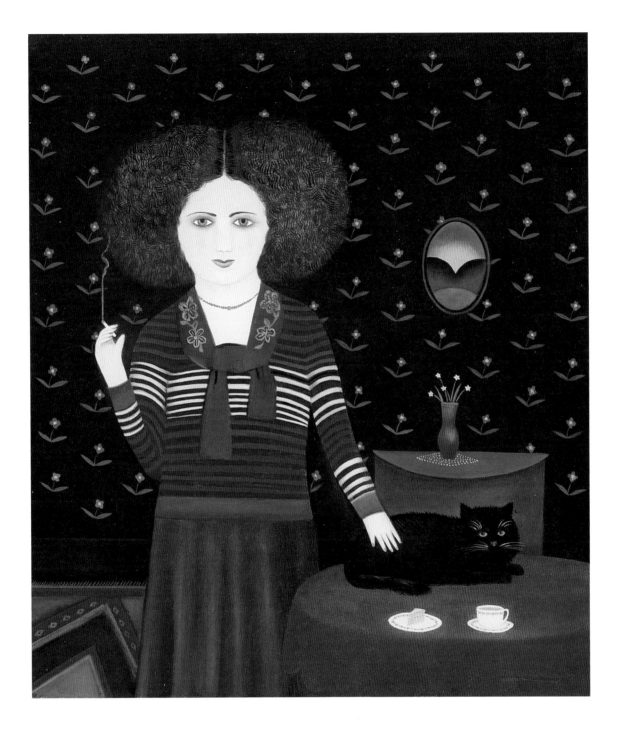

Girl with cat
Oil on board 41 x 35.5*cm* 1974

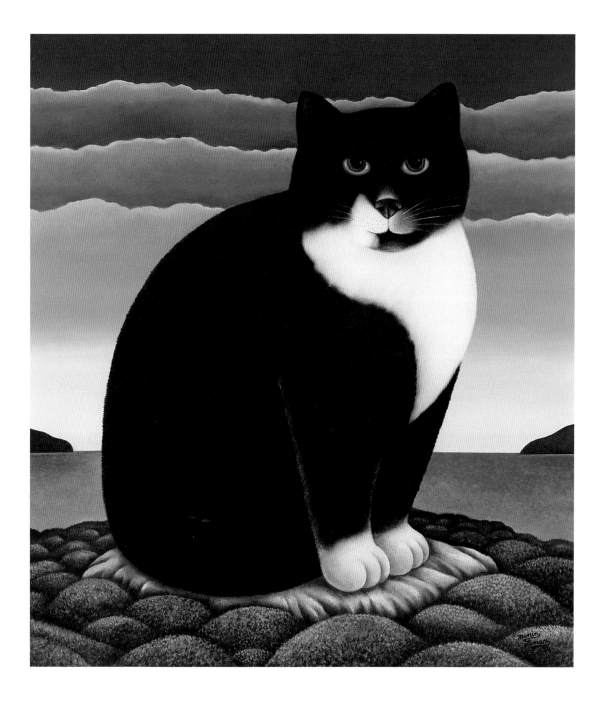

Caroline's Cat
Oil on board 46 x 41*cm* 1980

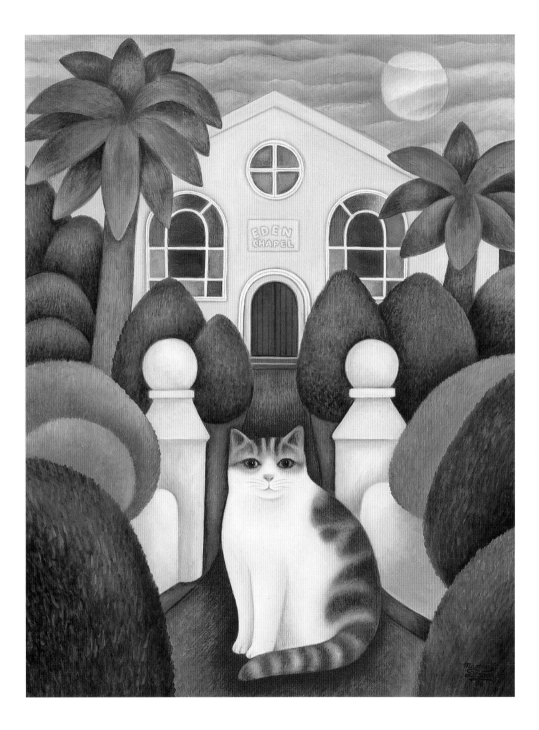

Eden Chapel
Oil on board 35.5 x 25.5*cm* 1976

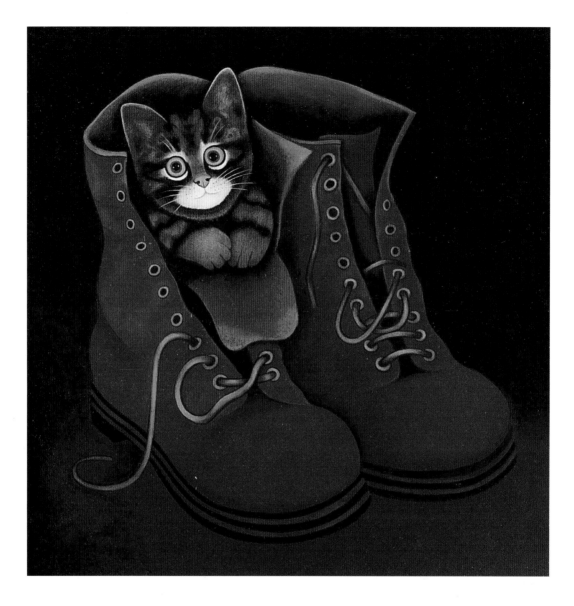

Painting from 'Comic & Curious Cats'
Oil on board 30.5 x 30.5*cm* 1977

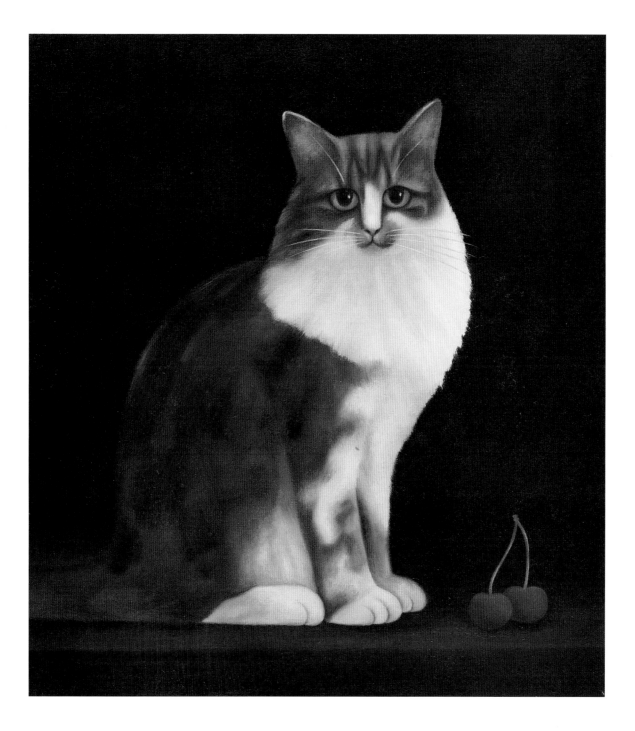

Amber
Oil on board 49 x 43*cm* 1991

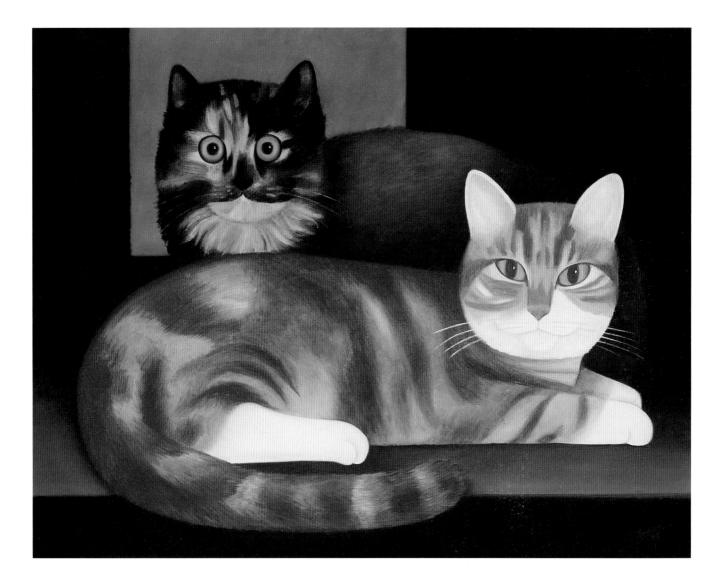

Annie and Macavity
Oil on board 30 x 38*cm* 1998

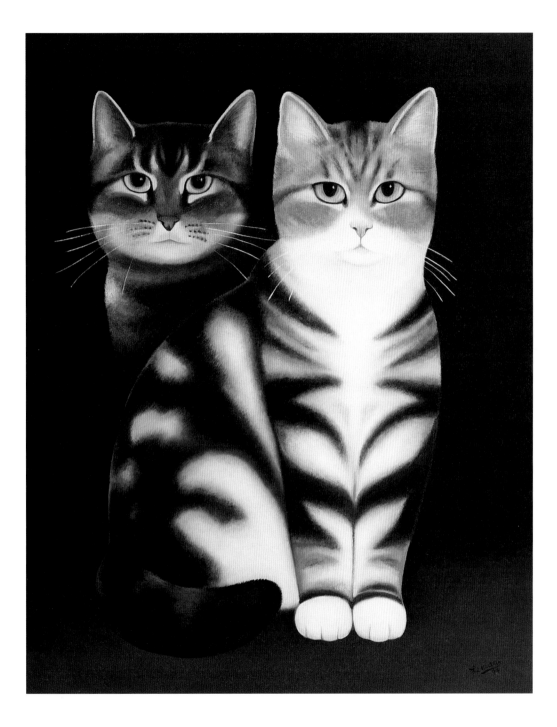

Stripes and Goldie
Oil on board 38 x 30 cm 1994

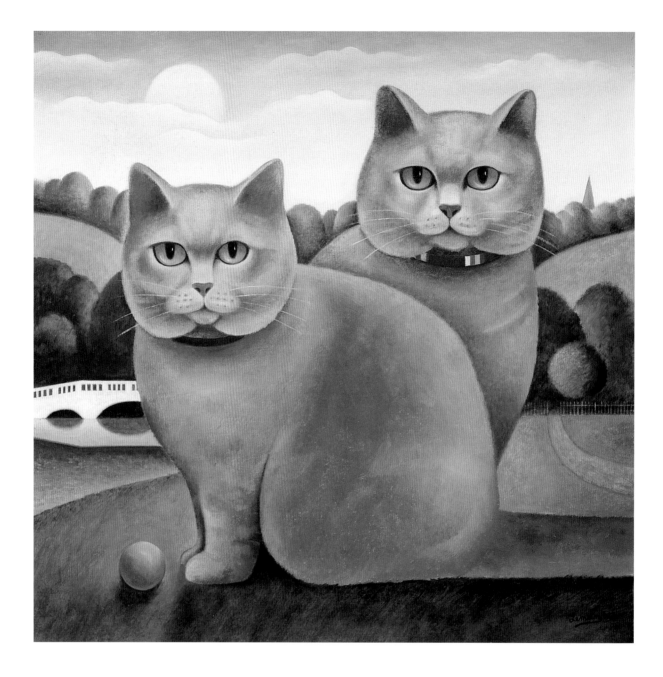

Puss & Puss, Hampstead Heath
Oil on board 30 x 30 cm 1997

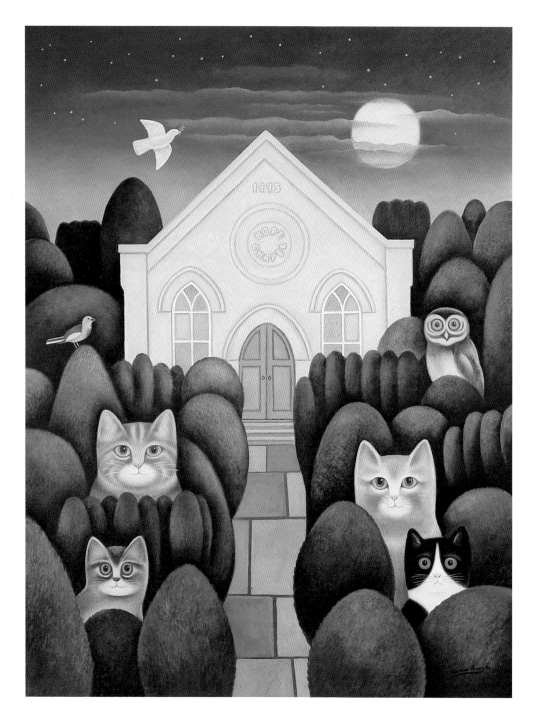

Peaceful evening
Oil on board 38 x 25 *cm* 1994

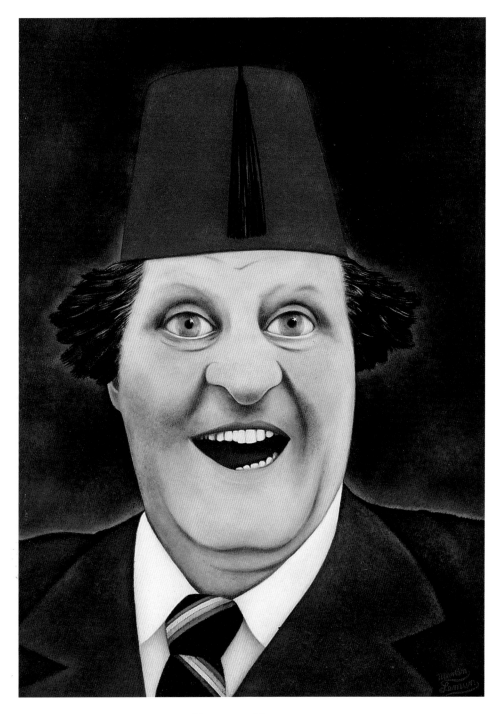

Tommy Cooper
Oil on board 30.5 x 25.5*cm* 1983

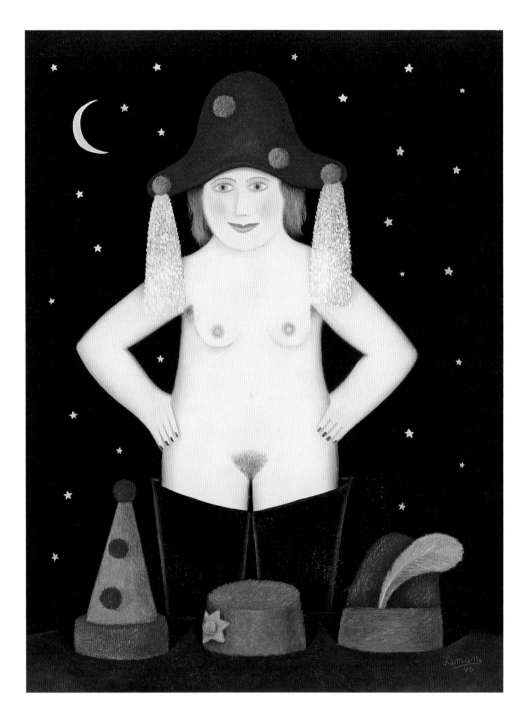

Party time — which hat?
Oil on board 25.5 x 15*cm* 1996

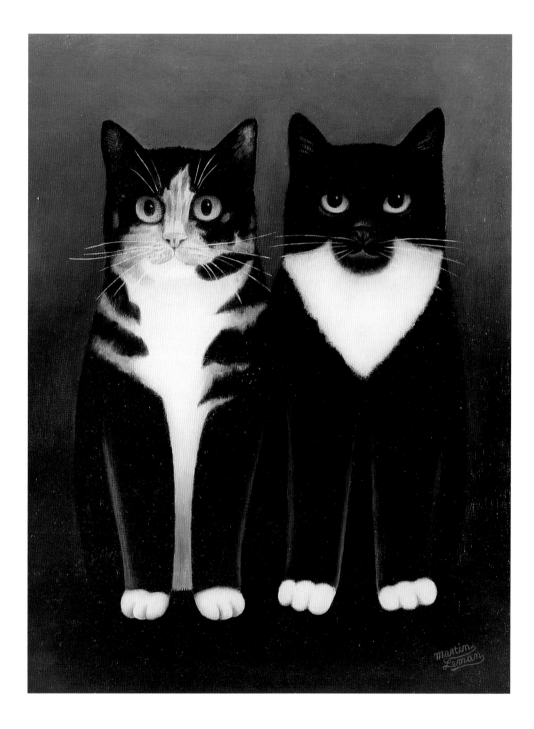

Penny Black & Tiffany Tortoiseshell
Oil on board 33 x 25*cm* 1987

Rosie
Oil on board 30.5 x 30.5*cm* 1985

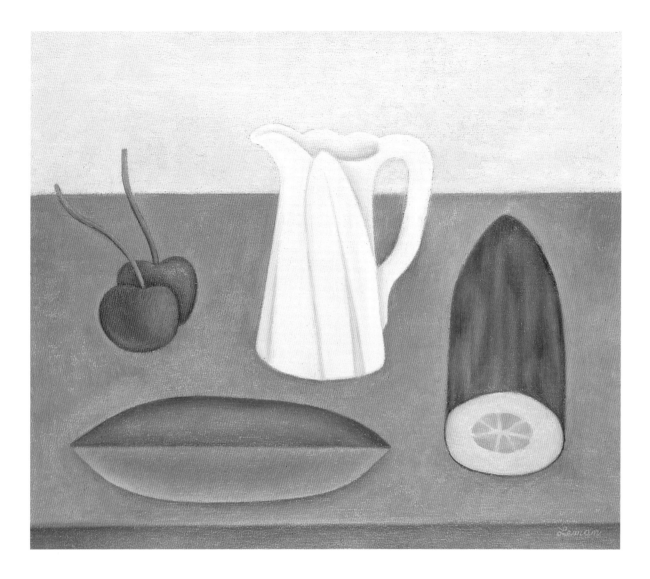

Green Piece
Oil on board 25.5 x 30.5*cm* 1991

Cornwall
Oil on board 30.5 x 24*cm* 1991

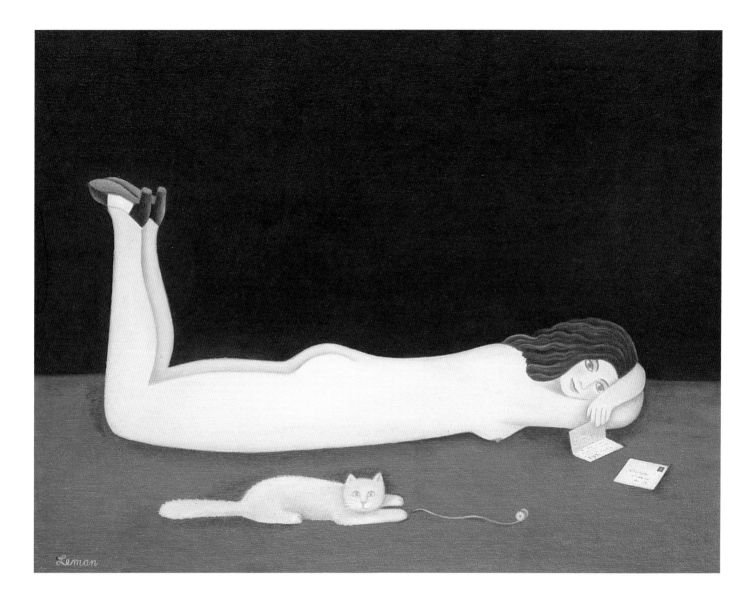

Love letters
Oil on board 25.5 x 38*cm* 1991

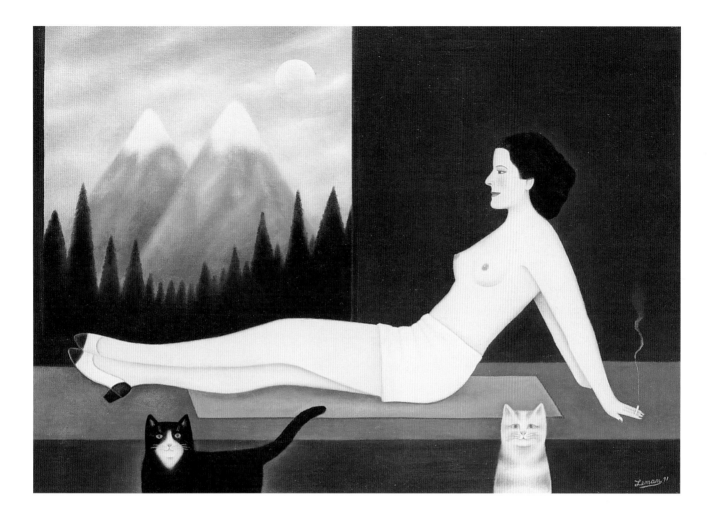

Twin Peaks
Oil on board 25.5 x 38*cm* 1991

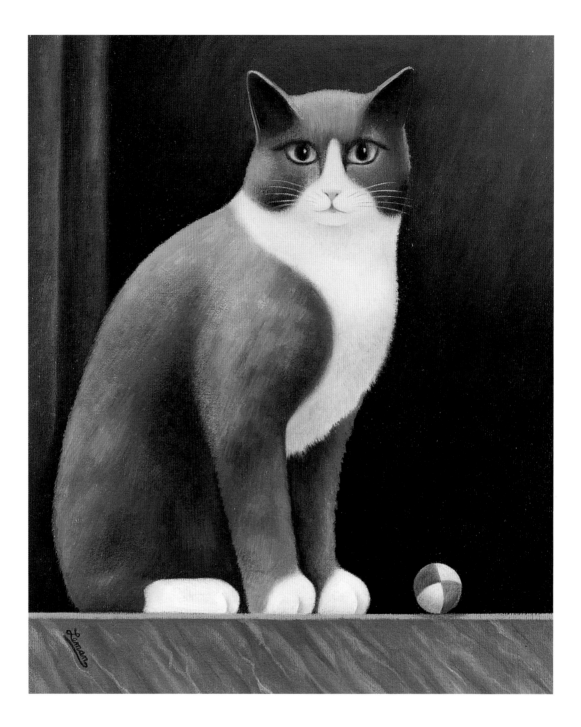

Lloyd
Oil on board 29 x 24*cm* 1989

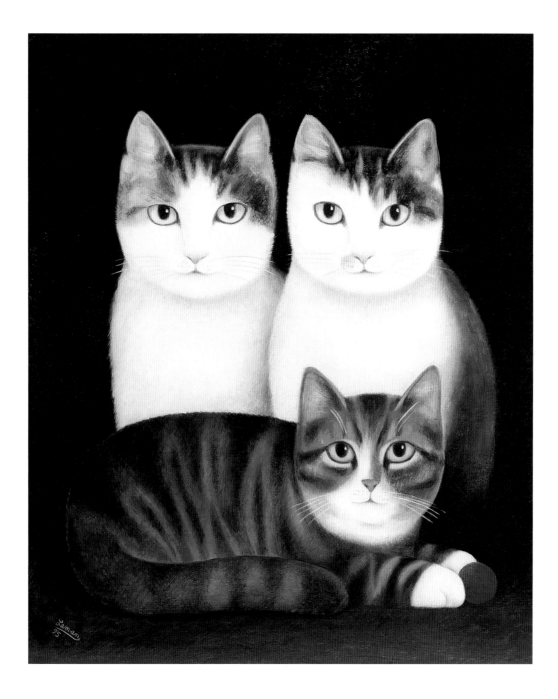

Sunny, Moony & Snuffy
Oil on board 25.5 x 20*cm* 1995

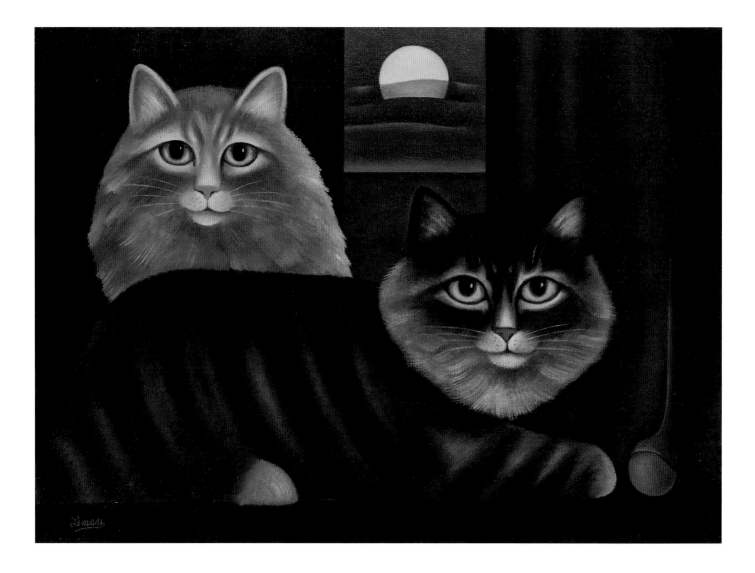

Sears & Roebuck
Oil on board 25.5 x 38*cm* 1991

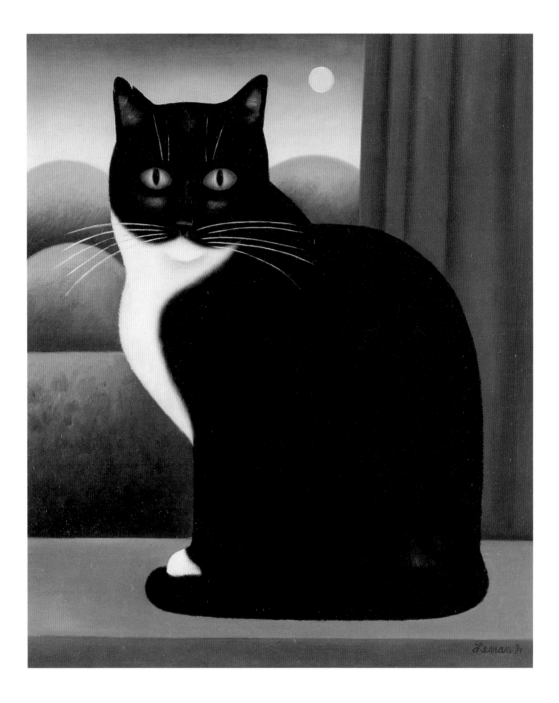

Boris
Oil on board 25.5 x 20*cm* 1991

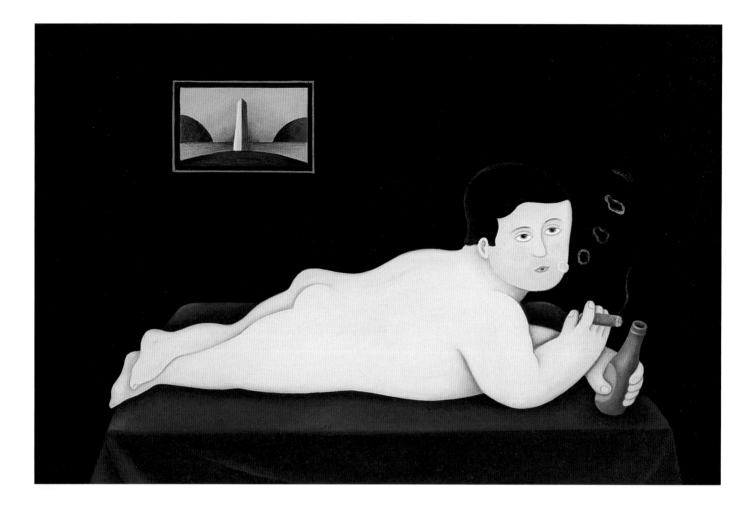

Smoke Rings
Oil on board 28 x 43 *cm* 1995

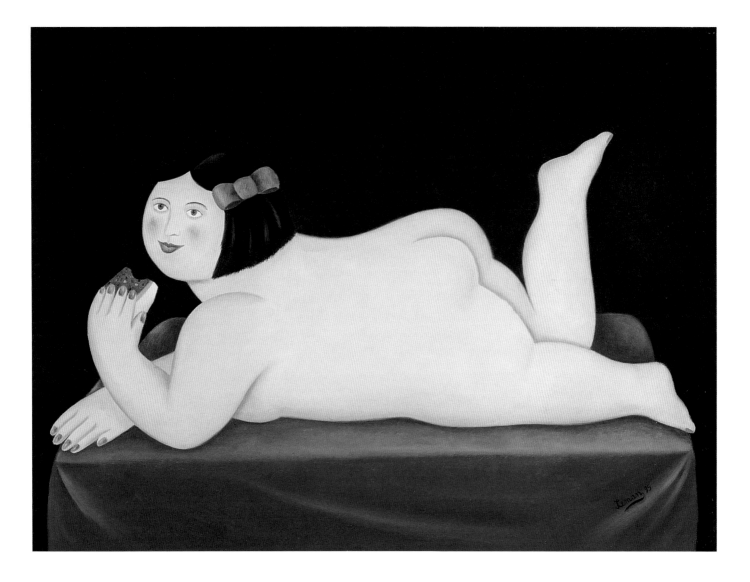

A piece of cake
Oil on board 28 x 38*cm* 1995

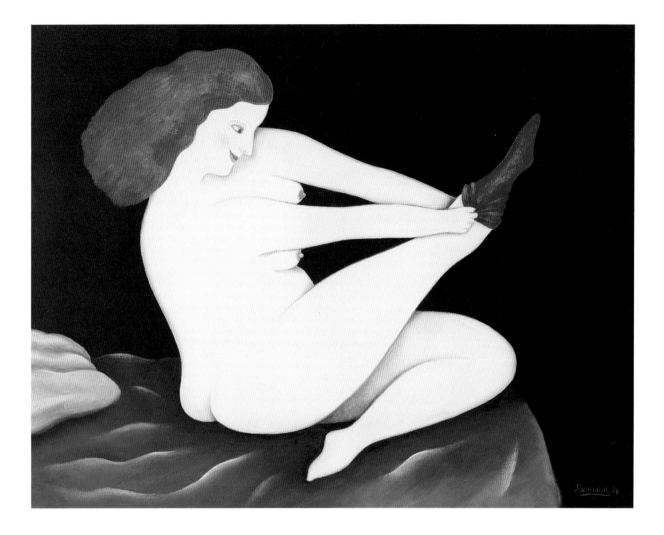

Red Stocking
Oil on board 20 x 25*cm* 1996

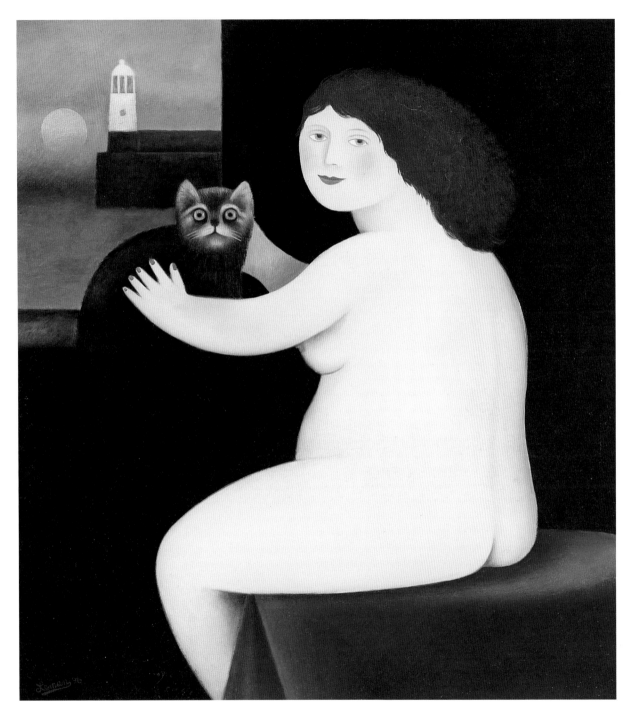

Harbour view
Oil on board 33 x 30 *cm* 1996

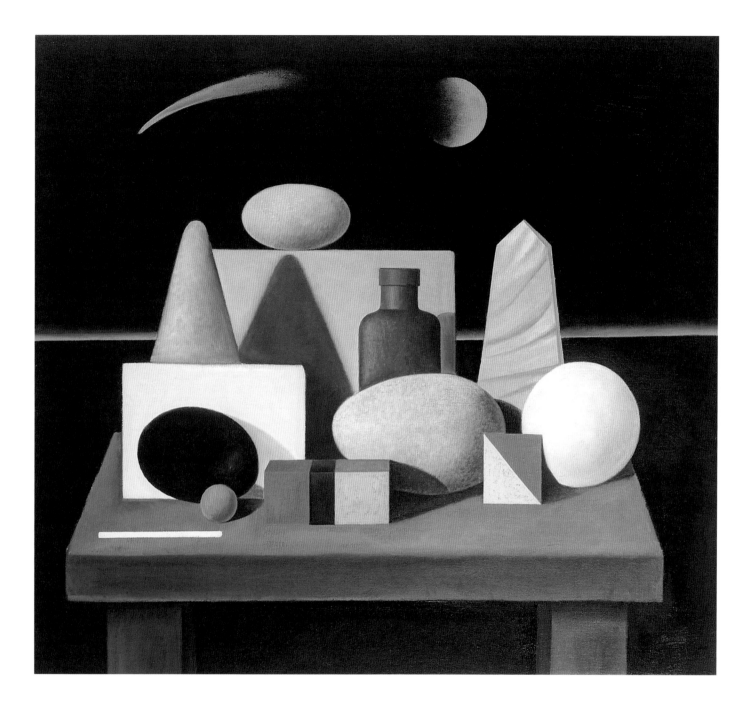

Nocturne
Oil on board 46 x 51*cm* 1996

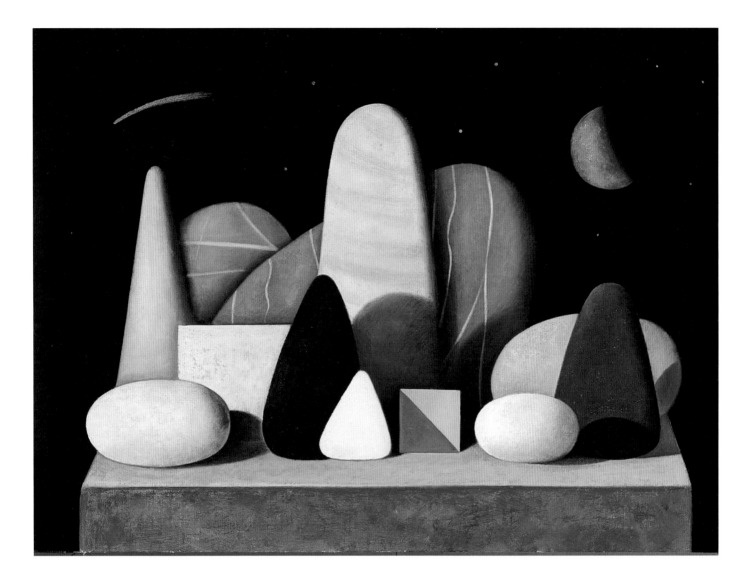

Monolith
Oil on board 31 x 45*cm* 1996

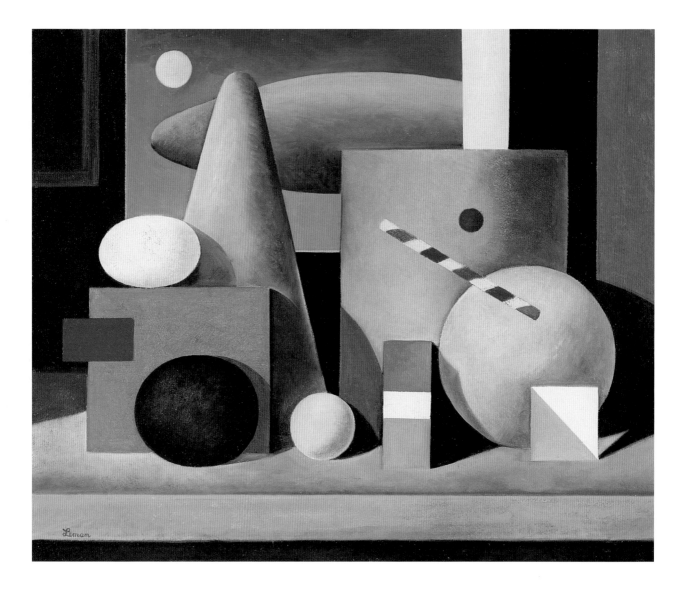

Touch of magic
Oil on board 24 x 30.5 *cm* 1995

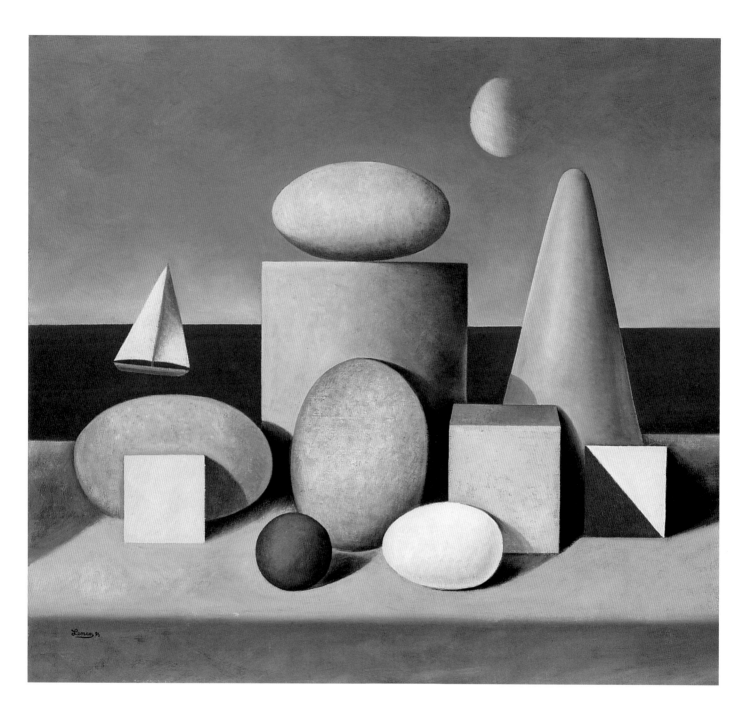

Interlude
Oil on board 46 x 51*cm* 1996

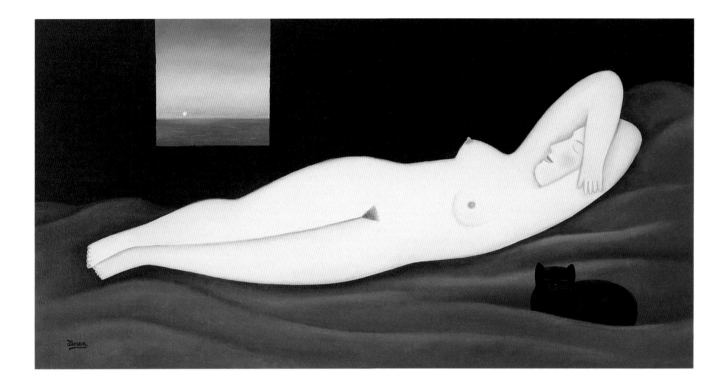

Dreamimg
Oil on board 35.5 x 18*cm* 1998

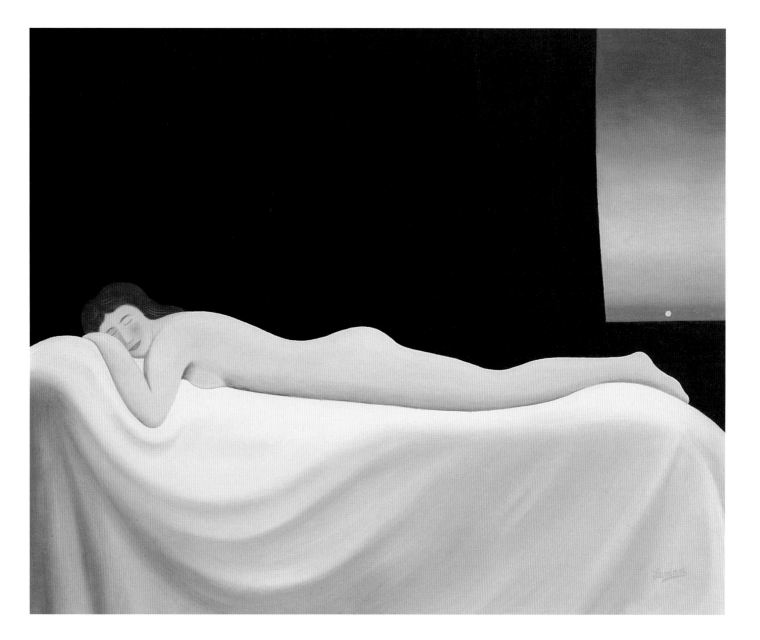

Sleeping Model
Oil on board 36 x 45 *cm* 2002

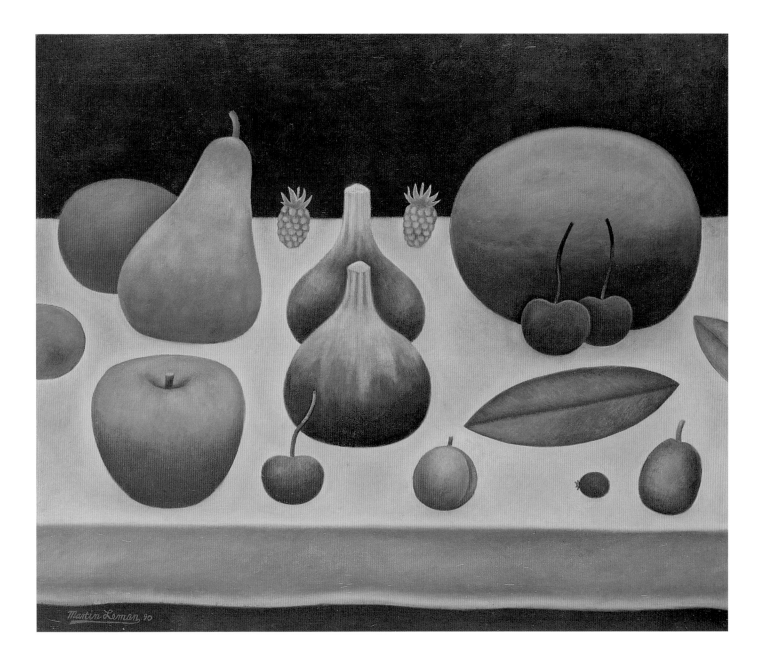

Fruit
Oil on board 39 x 48*cm* 1990

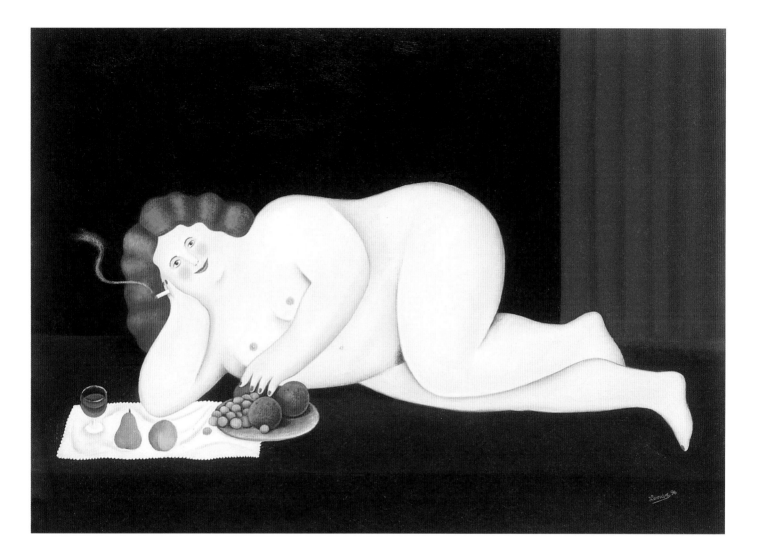

Nude with fruit
Oil on board 43 x 58.5*cm* 1996

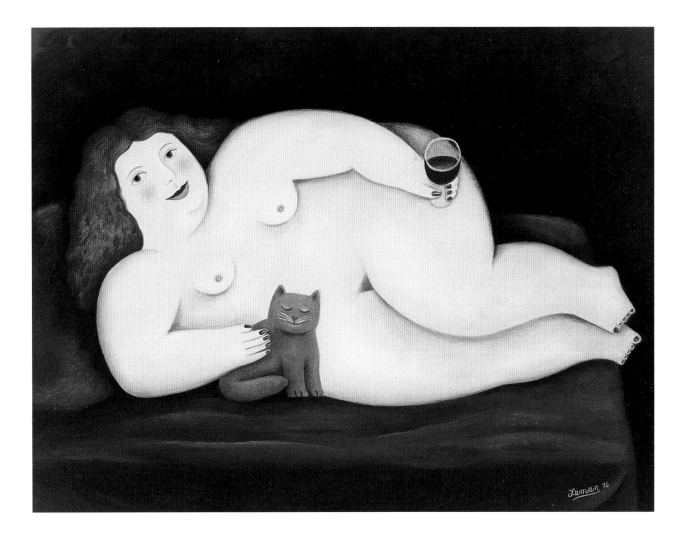

A glass of wine
Oil on board 24 x 30 *cm* 1996

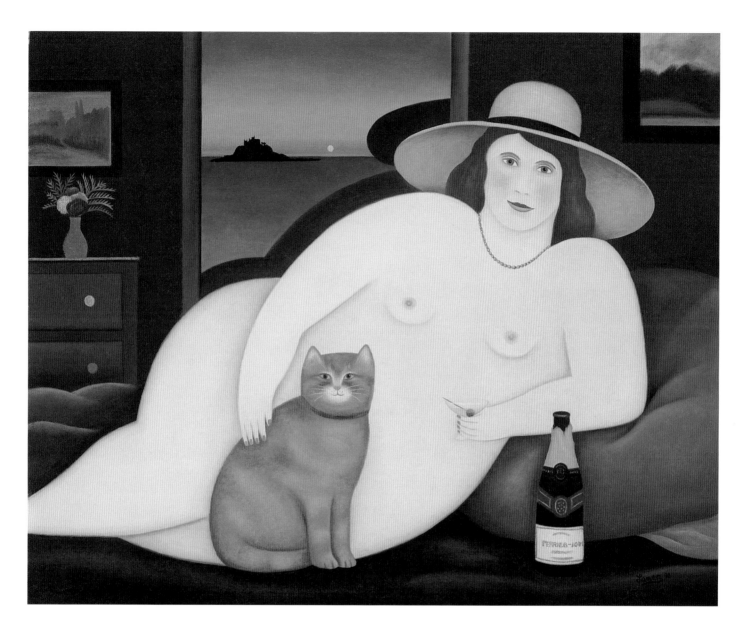

Room with a view
Oil on board 43 x 58*cm* 1998

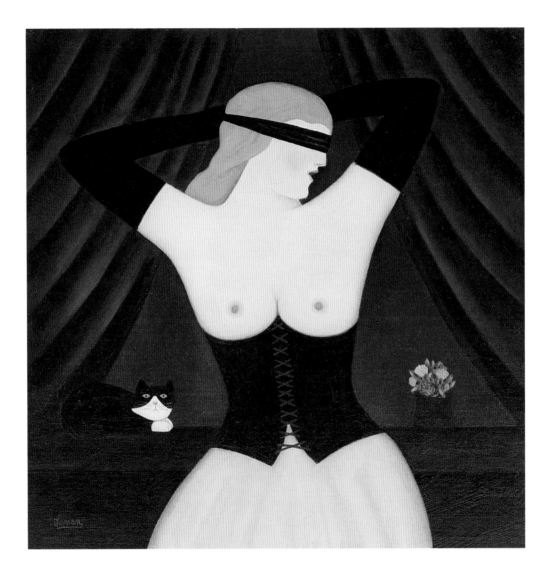

Blind Date
Oil on board 30.5 x 30.5 *cm* 2001

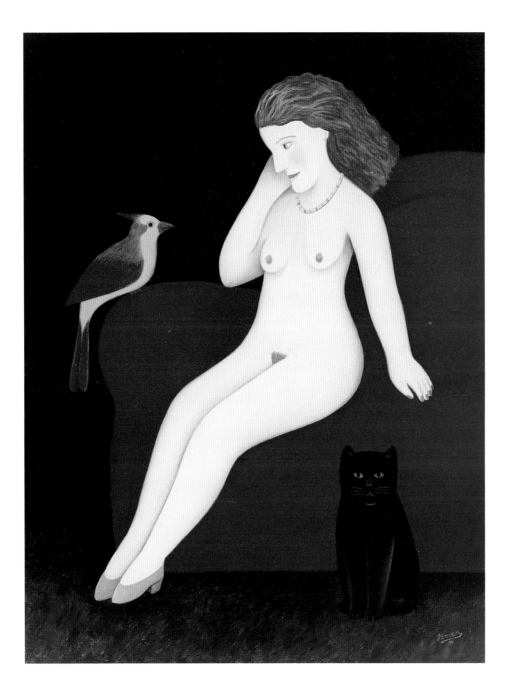

Exotic Bird
Oil on board 25.5 x 20 *cm* 1996

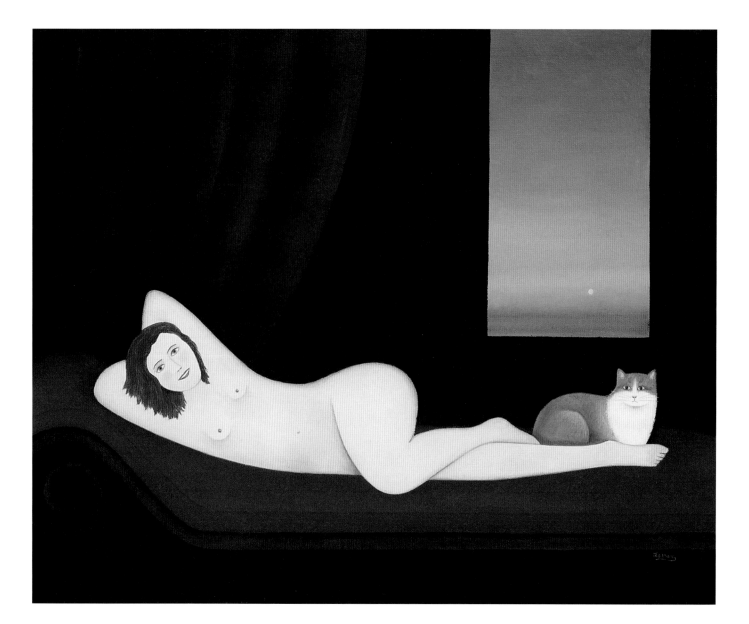

Reclining nude
Oil on board 30.5 x 38cm 1999

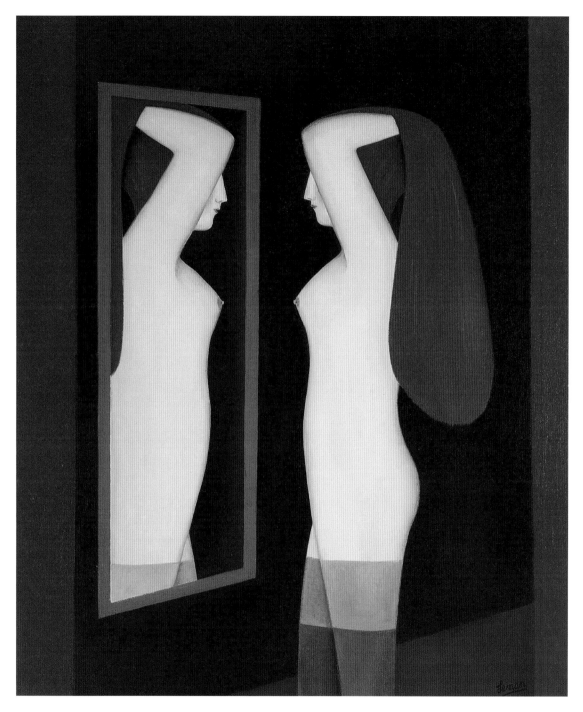

Mirror, mirror
Oil on board 61 x 51*cm* 2000

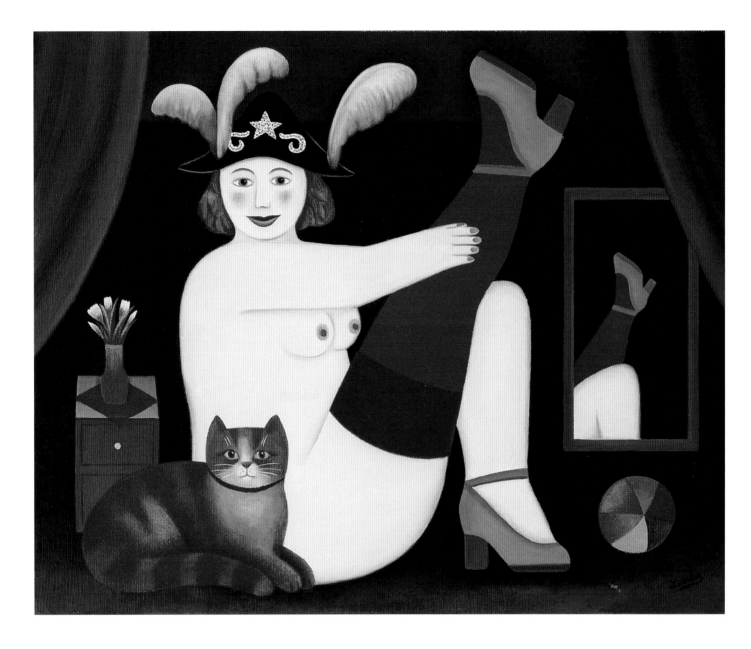

Red stocking
Oil on canvas 33 x 39*cm* 2000

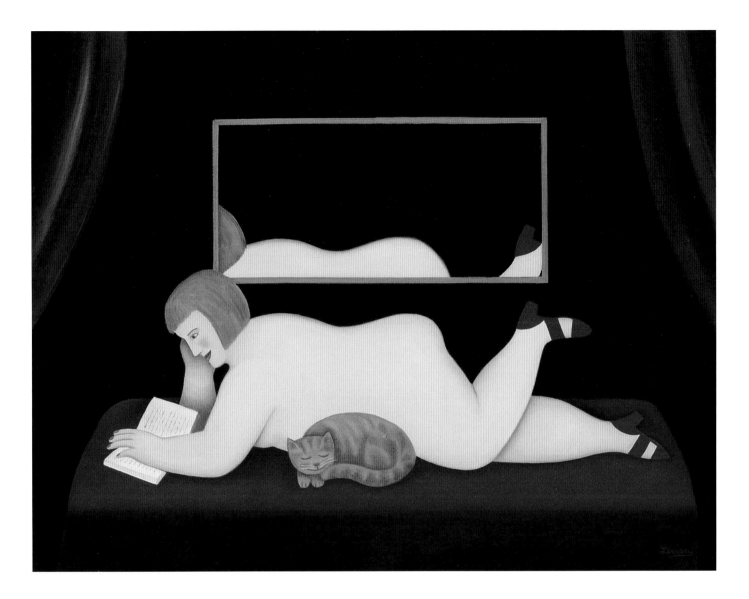

Book at bedtime
Oil on board 33 x 41*cm* 1998

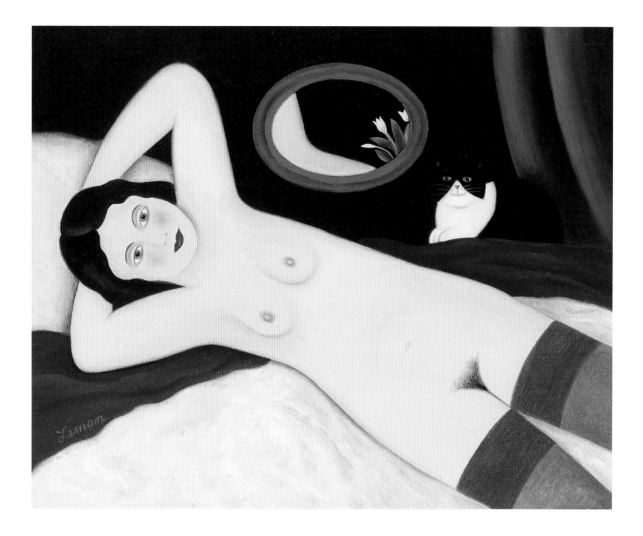

Laid back
Oil on board 20 x 25*cm* 1999

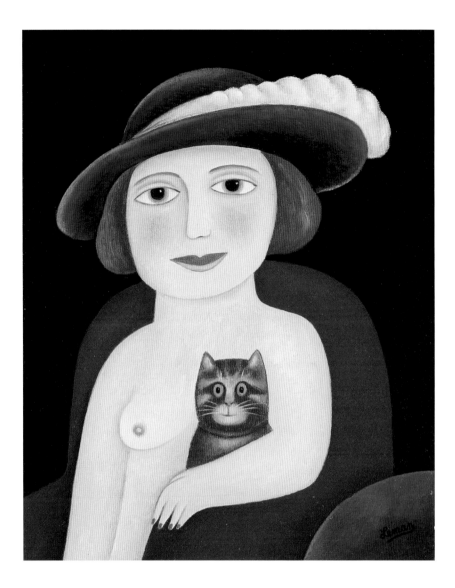

A Feather in my hat
Oil on board 25 x 20*cm* 1999

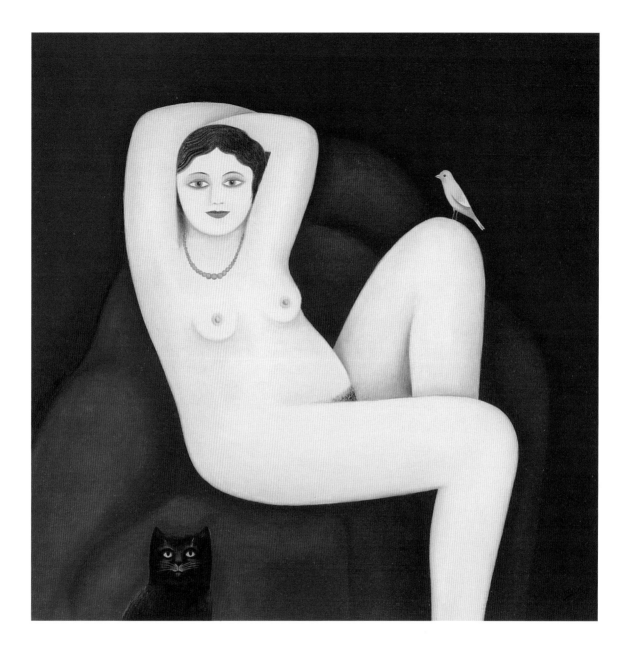

Cat & Canary
Oil on board 30 x 30 *cm* 1996

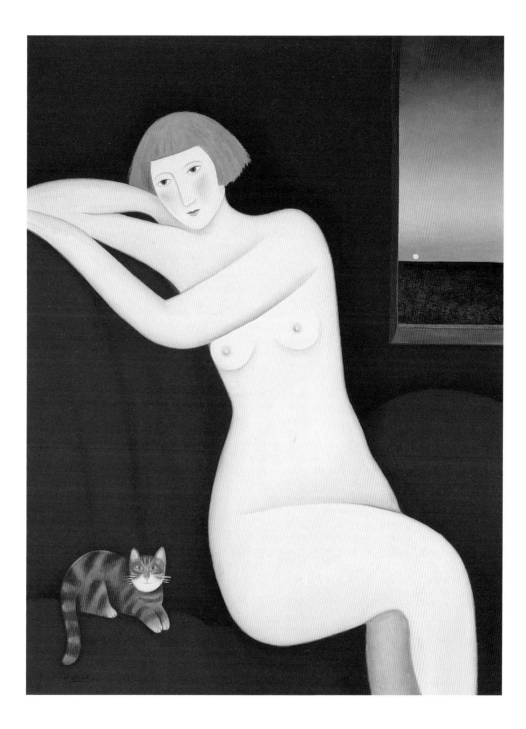

Far away
Oil on board 30 x 25 *cm* 1999

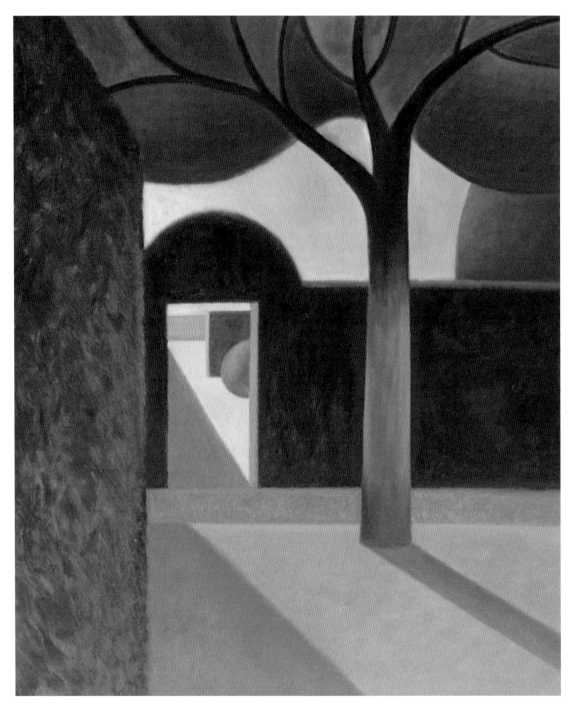

Garden Entrance
Oil on board 61 x 53*cm* 2000

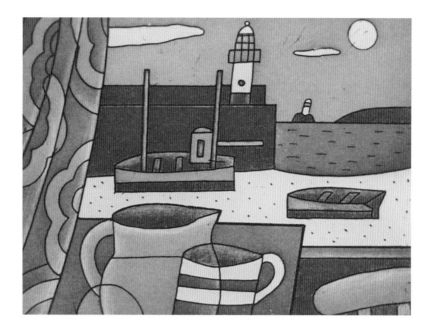

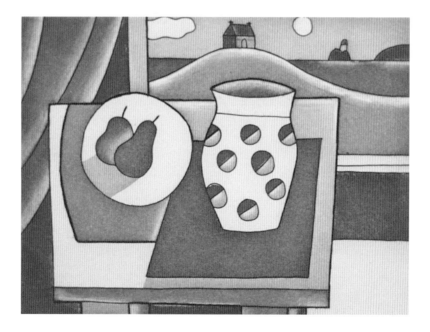

The Harbour
Etching 10 x 15*cm* 1994

The Island
Etching 10 x 15*cm* 1994

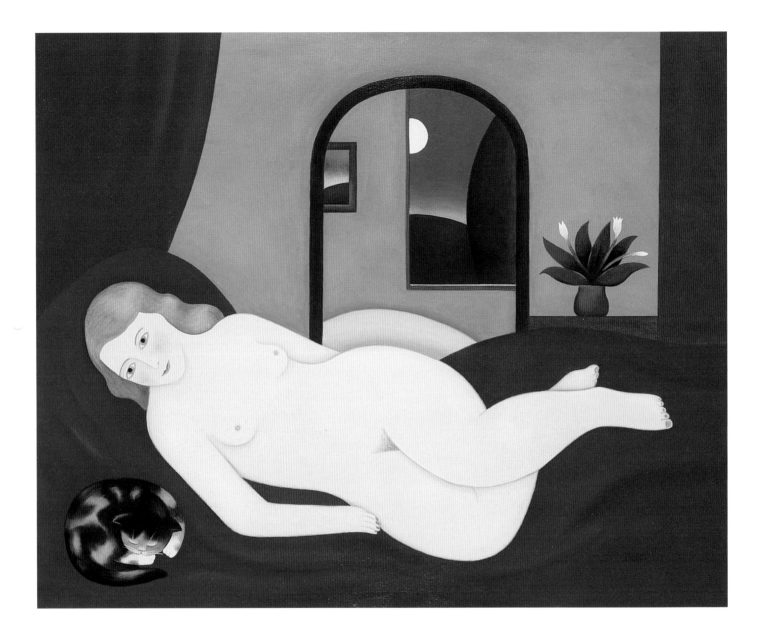

Evening rest
Oil on board 40.5 x 51*cm* 1999

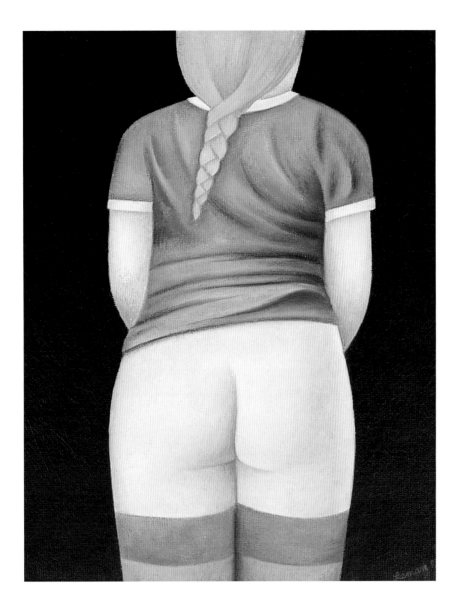

Changing for games
Oil on board 25 x 20 *cm* 1993

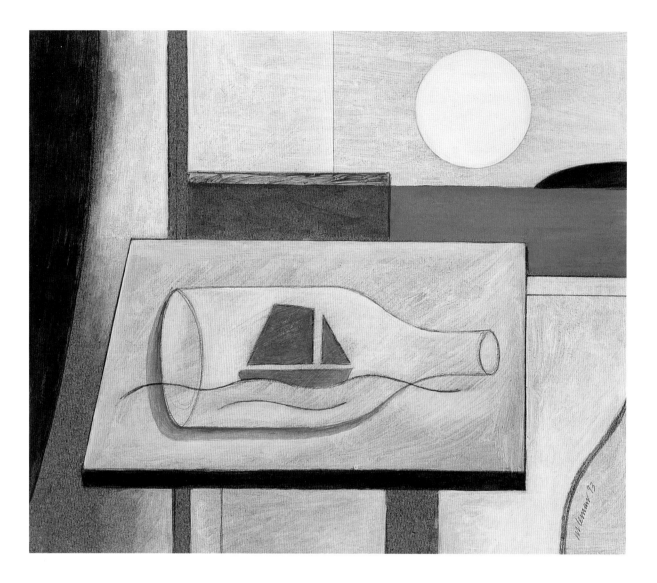

Ship in a bottle
Mixed media 21 x 25cm 1993

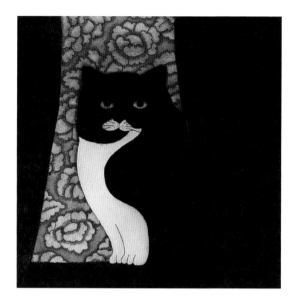

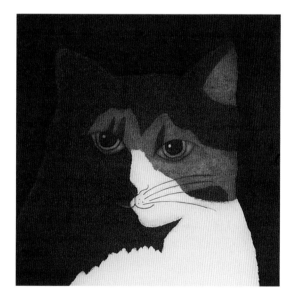

Scruffty
Etching 15 x 15*cm* 1981

Ben
Etching 15 x 15*cm* 1989

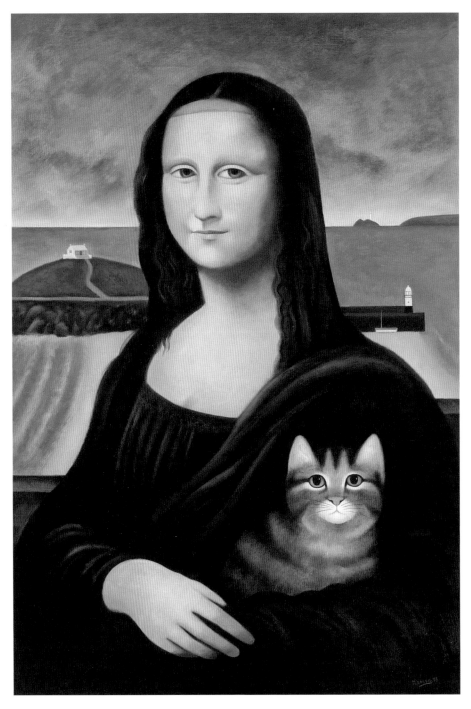

Did Leonardo visit St Ives?
Oil on canvas 76.5 x 51*cm* 1998

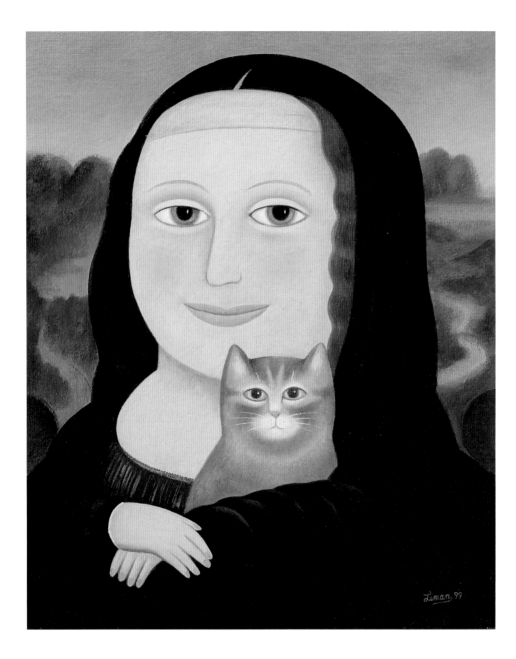

Mona Lisa
Oil on board 24 x 19 *cm* 1999

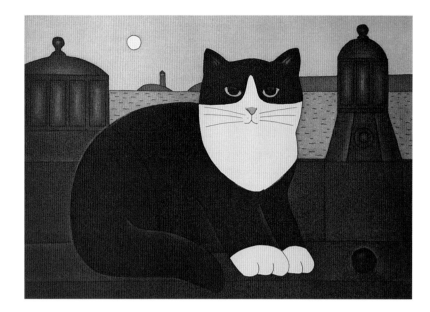

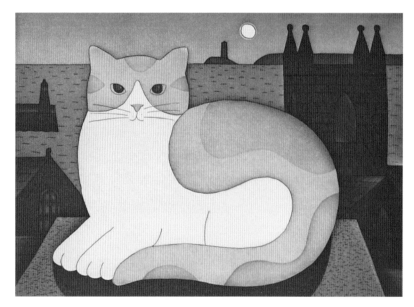

Harbour view
St Ives, Etching 20 x 28*cm* 1985

Terrace view
St Ives, Etching 20 x 28*cm* 1985

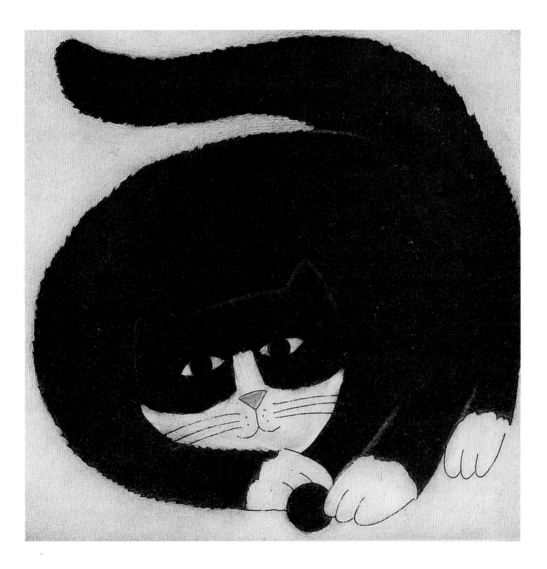

Waiting
Etching 15 x 15*cm* 1998

Mog and Pelusa
Oil on board 30.5 x 25cm 2000

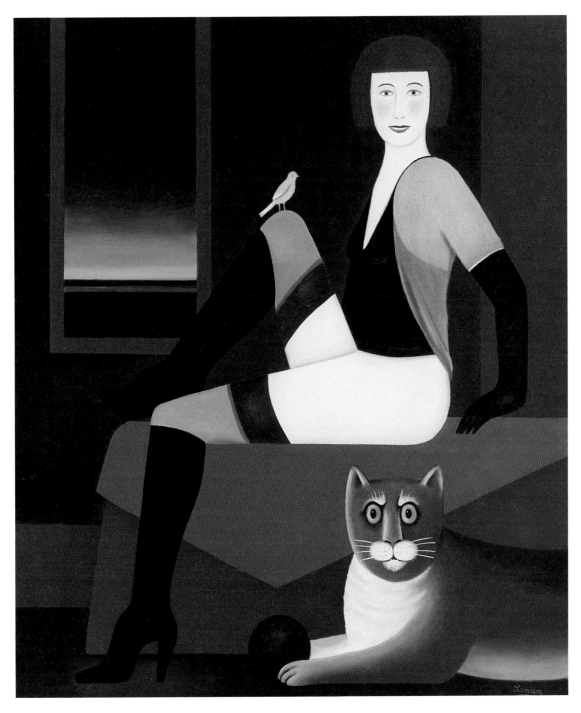

An evening with friends
Oil on board 61.5 x 51*cm* 2001

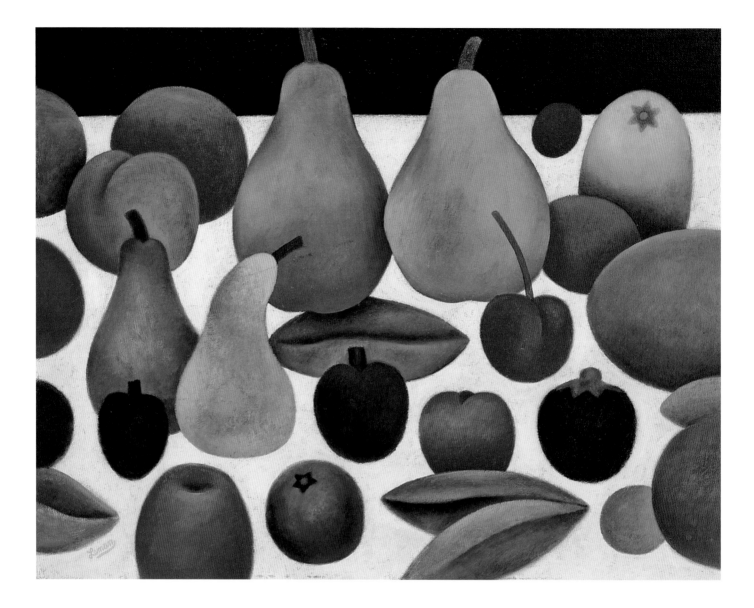

Fruit
Oil on board 40.5 x 51*cm* 2001

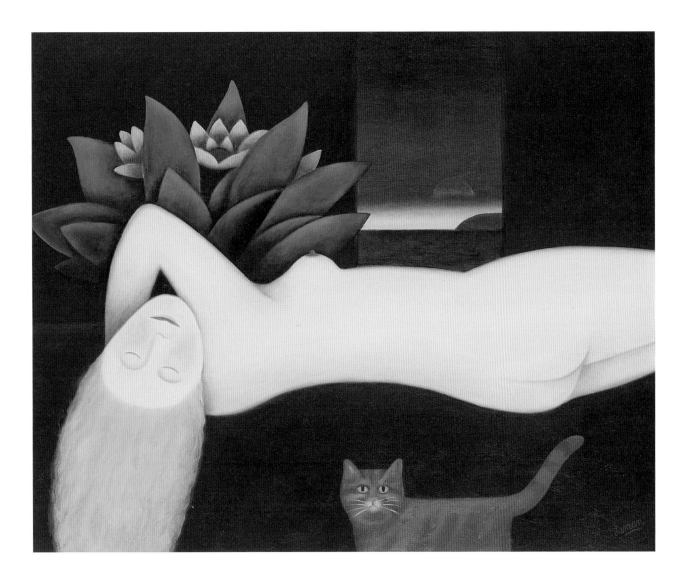

Laid Back
Oil on board 31 x 38*cm* 2002

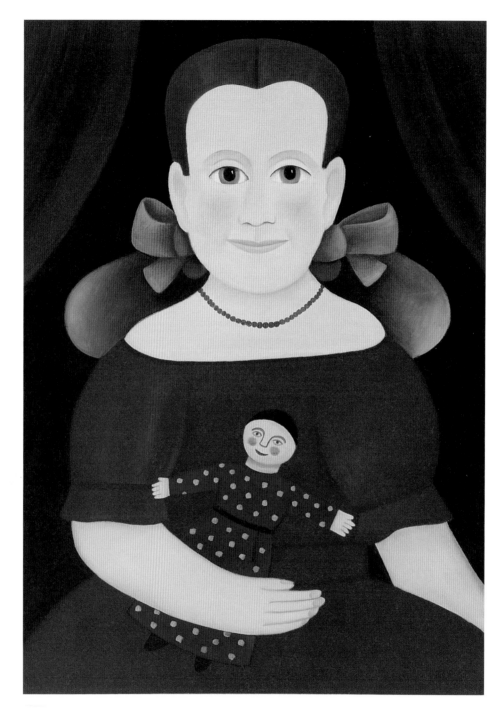

Girl with rag doll
Oil on board 46 x 33 *cm* 2002

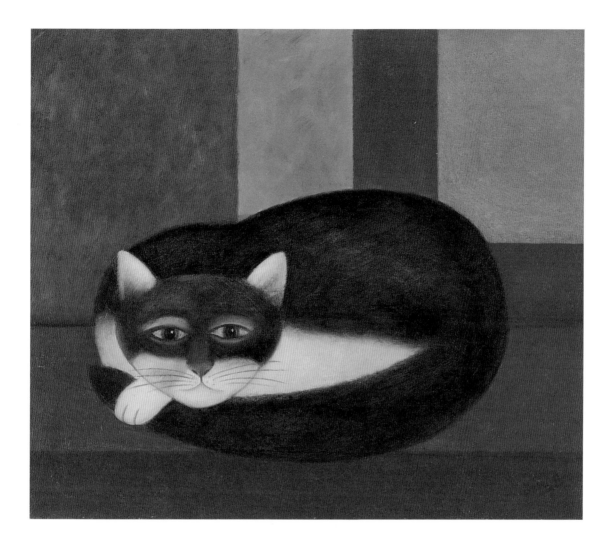

Brown Cat
Oil on board 25 x 31*cm* 2002

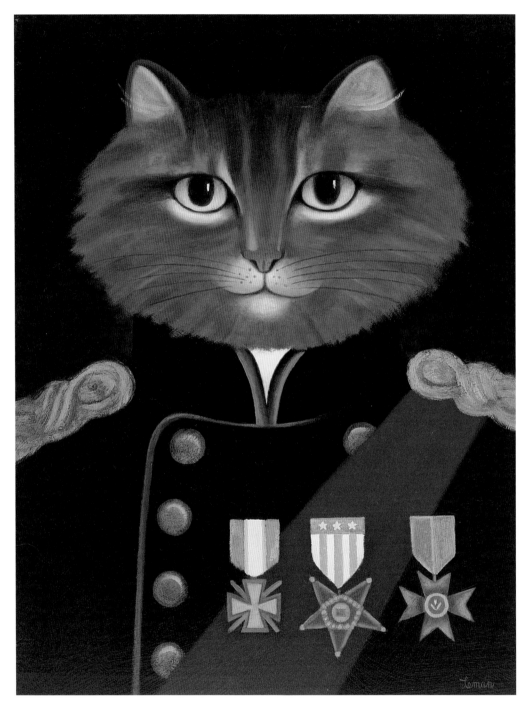

The General
Oil on board 41 x 31*cm* 2002

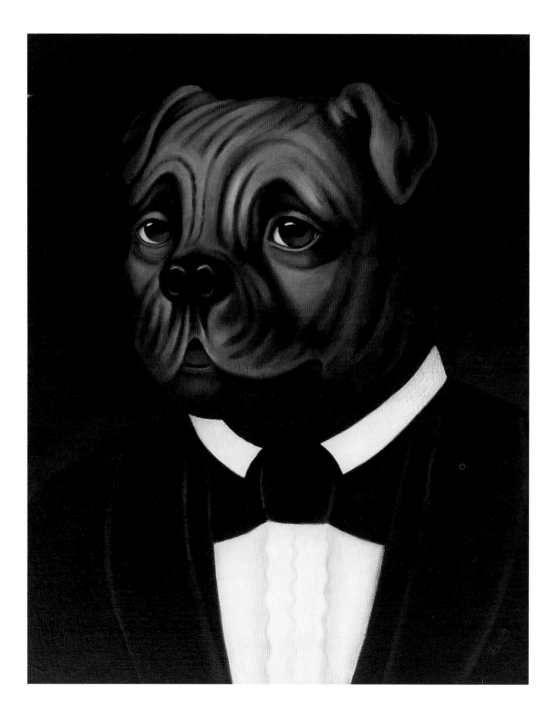

Major Barker
Oil on board 51 x 40 *cm* 2002

Solo Exhibitions

1971 Portal Gallery, London

1974 Portal Gallery, London

1979 Graffiti Gallery, London

1980 Graffiti Gallery, London
Illustrators Gallery, London

1981 Print Show, Gallery 39, Manchester
Graffiti Gallery, London

1982 Graffiti Gallery, London

1986 Blackman Harvey, London

1987 Cat's Meow Gallery, Tokyo, Japan

1988 Blackman Harvey, London
Michael Parkin Gallery, London

1990 Andrew Usiskin Contemporary Art, London

1991 Andrew Usiskin Contemporary Art, London

1992 Andrew Usiskin Contemporary Art, London

1996 Coram Gallery, London

1998 Portal Gallery, London

1999 Rona Gallery, London
Wren Gallery, Burford

2001 Rona Gallery, London
Wren Gallery, Burford

2002 Rona Gallery, London

Selected Group Exhibitions

1973 INTERNATIONAL PRIMITIVE ART EXHIBITION
Zagreb, Yugoslavia

1975 CENTRE CULTUREL DE LEVALLOIS-PERRET,
Paris, France
ART NAIF, Galerie Contemporaine,
Geneva, Switzerland

1976 BODY AND SOUL, Arts Council Exhibition,
Walker Art Gallery, Liverpool

1977 BRITISH NAÏVES, Ikon Gallery, Birmingham

1978 LONDON NAÏVE ART
Royal Festival Hall, London

1979 INTERNATIONAL NAÏVE ART
Hamiltons Gallery, London

1993 THE BRITISH ART OF ILLUSTRATON 1780-1993
Chris Beetles Gallery, London

1998 CHILDREN'S BOOK ILLUSTRATIONS
Cambridge Contemporary Art, Cambridge

2001 THE DISCERNING EYE, selected by Sir Roy Strong,
Mall Galleries, London

Exhibitions in St Ives, Cornwall

1980-1990s Royal Academy Summer Exhibitions over the last 15 years

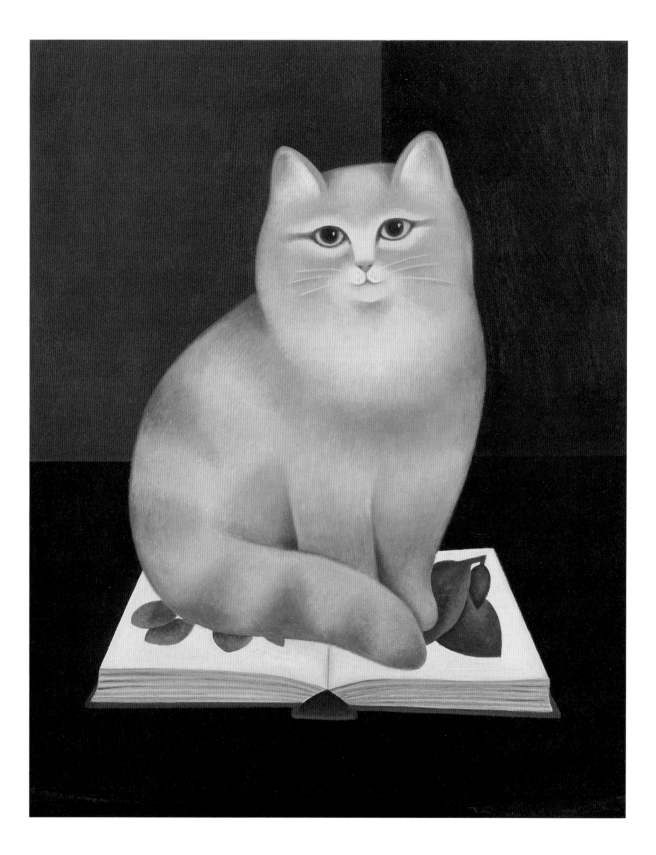

Martin Leman Books

1979 COMIC & CURIOUS CATS, *Gollancz*

1980 THE BOOKS OF BEASTS, *Gollancz*
STARCATS, *Pelham Books*

1981 TEN CATS AND THEIR TALES, *Pelham Books*

1982 TWELVE CATS FOR CHRISTMAS, *Pelham Books*

1983 THE PERFECT CAT, *Pelham Books*

1984 LOVELY LADIES, *Pelham Books*

1985 A WORLD OF THEIR OWN, *Pelham Books*

1986 CAT'S COMPANION, *Pelham Books*

1987 CATSNAPS, *Pelham Books*

1988 PAINTED CATS, *Pelham Books*
THE TEENY WEENY CAT BOOK, *Pelham Books*

1989 MARTIN LEMAN'S TEDDY BEARS, *Pelham Books*

1990 NEEDLEPOINT CATS, *Pelham Books*
THE LITTLE KITTEN BOOK, *Pelham Books*
CURIOUSER & CURIOUSER CATS, *Gollancz*

1991 THE CONTENTED CAT, *Pelham Books*
THE SQUARE BEAR BOOK, *Pelham Books*

1992 JUST BEARS, *Pelham Books*
MY CAT JEOFFRY, *Pelham Books*

1993 THE LITTLE CAT'S ABC BOOK, *Gollancz*
SLEEPY KITTENS, *Orchard Books*

1994 THE BEST OF BEARS, *Pelham Books*
CAT PORTRAITS, *Gollancz*

1995 TEN LITTLE PUSSY CATS, *Gollancz*

1996 MARTIN LEMAN'S CATS, *Brockhampton Press*

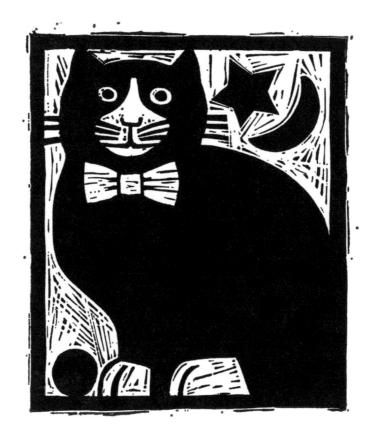